Colorful Blessings

CELEBRATING EVERYDAY WONDERS

VALERIE SJODIN

The Taunton Press

The Taunton Press, Inc.
63 South Main Street, PO Box 5506
Newtown, CT 06470-5506

Illustrator: Valerie Sjodin

Printed in the United States of America
10 9 8 7 6 5 4 3 2 1

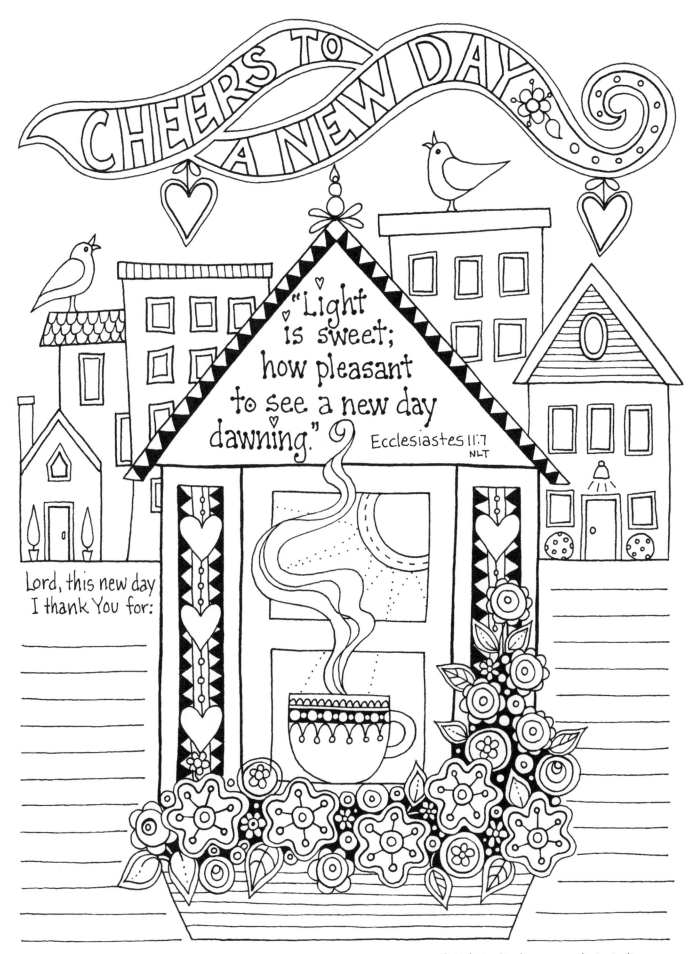

CHEERS TO A NEW DAY

"Light is sweet; how pleasant to see a new day dawning." Ecclesiastes 11:7 NLT

Lord, this new day I thank You for:

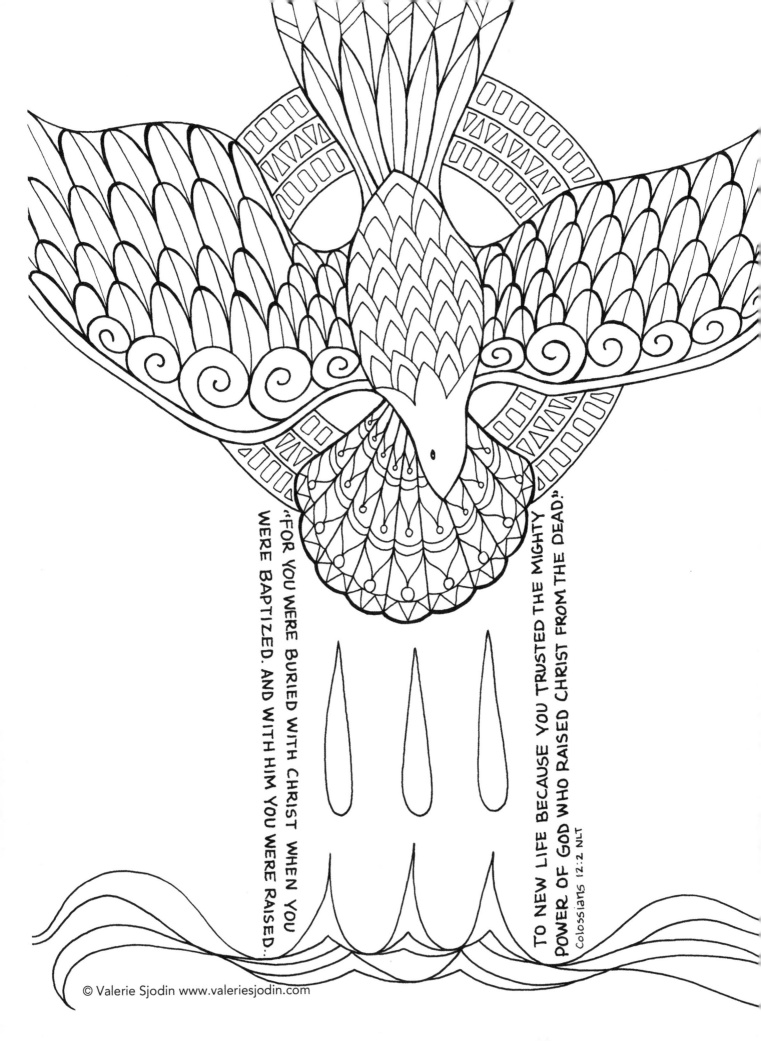

"FOR YOU WERE BURIED WITH CHRIST WHEN YOU WERE BAPTIZED. AND WITH HIM YOU WERE RAISED...

TO NEW LIFE BECAUSE YOU TRUSTED THE MIGHTY POWER OF GOD WHO RAISED CHRIST FROM THE DEAD." Colossians 12:2 NLT

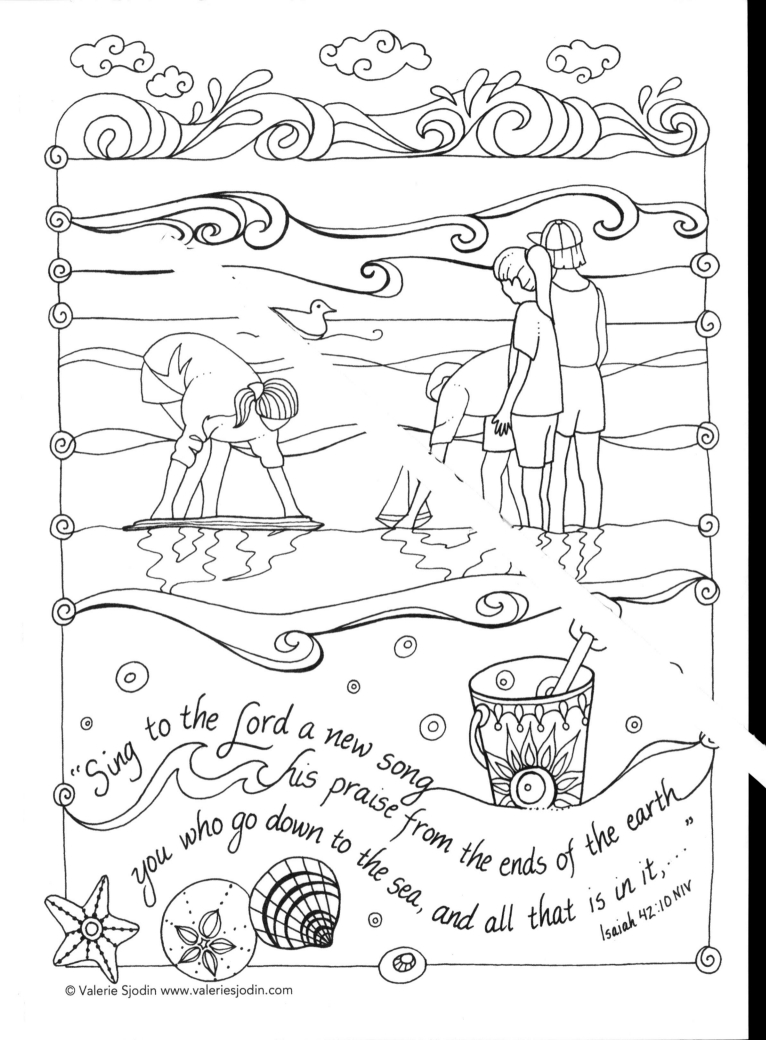

"Sing to the Lord a new song, his praise from the ends of the earth, you who go down to the sea, and all that is in it,..." Isaiah 42:10 NIV

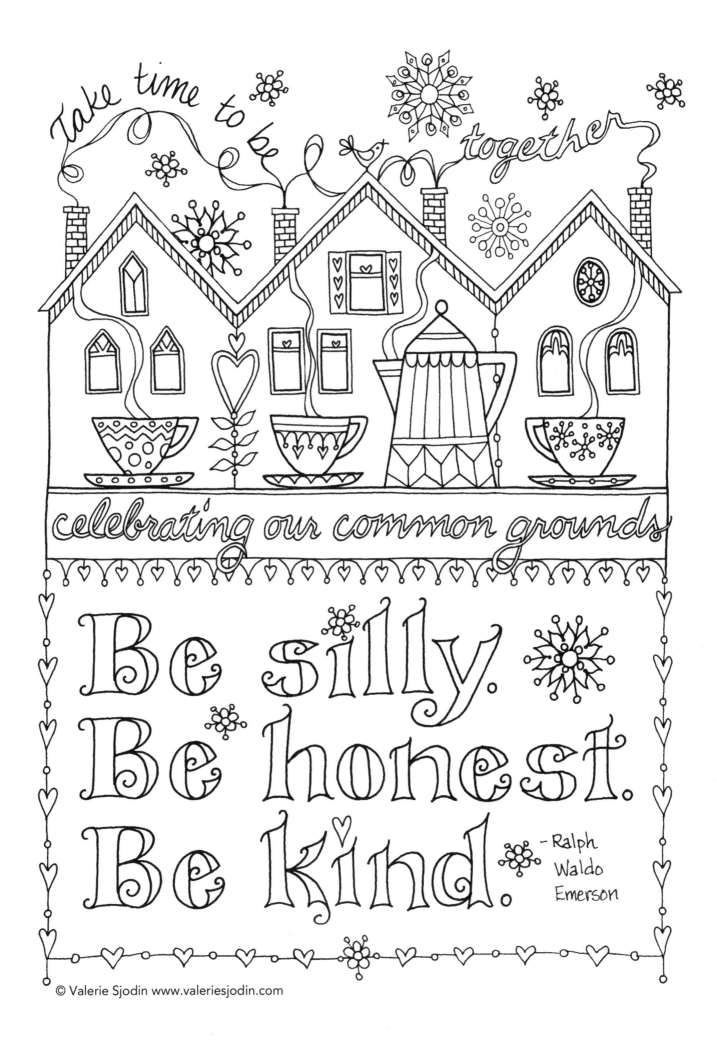

Take time to be together

celebrating our common grounds

Be silly.
Be honest.
Be kind. – Ralph Waldo Emerson

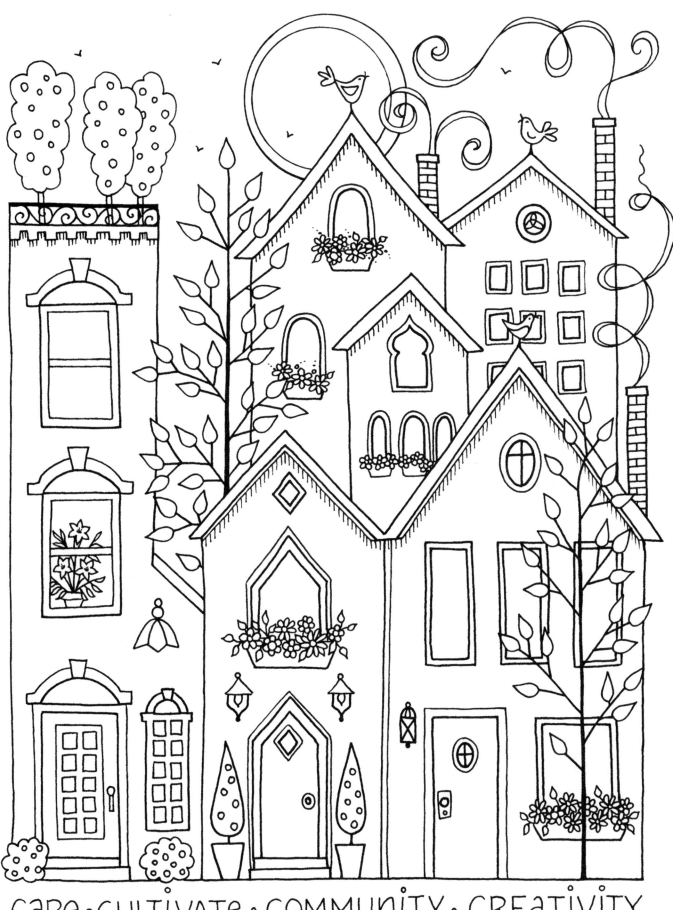

care · cultivate · community · creativity

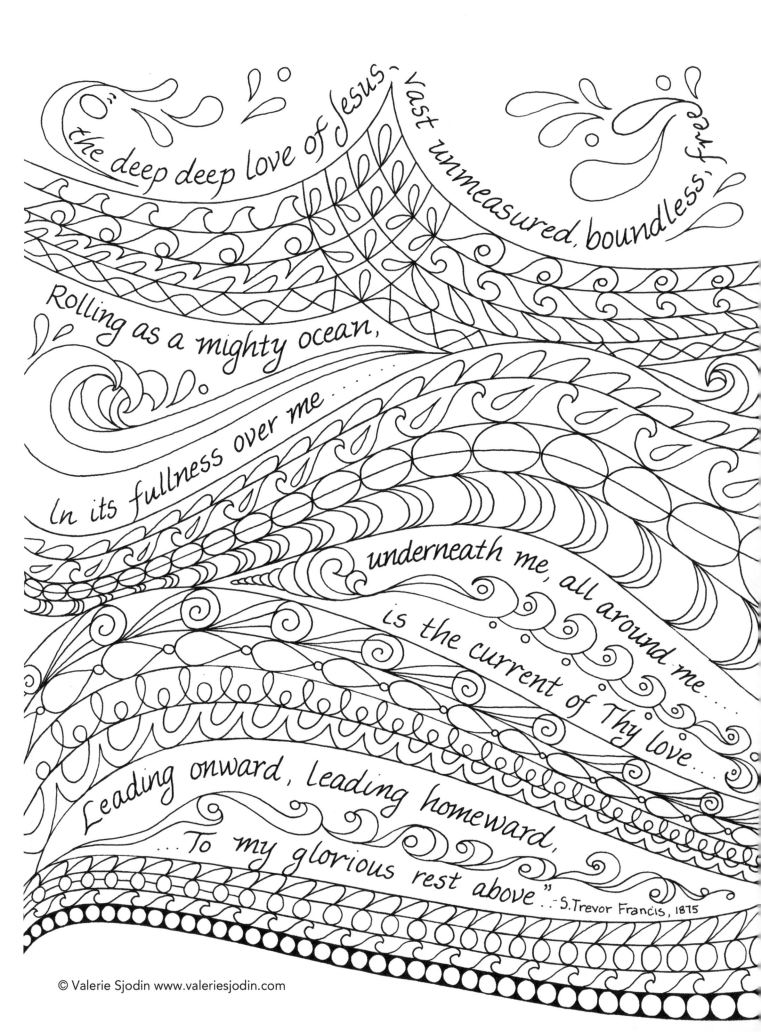

"O the deep deep love of Jesus, vast unmeasured, boundless, free

Rolling as a mighty ocean,

In its fullness over me......

underneath me, all around me......

is the current of Thy love......

Leading onward, leading homeward,

...To my glorious rest above" -S. Trevor Francis, 1875

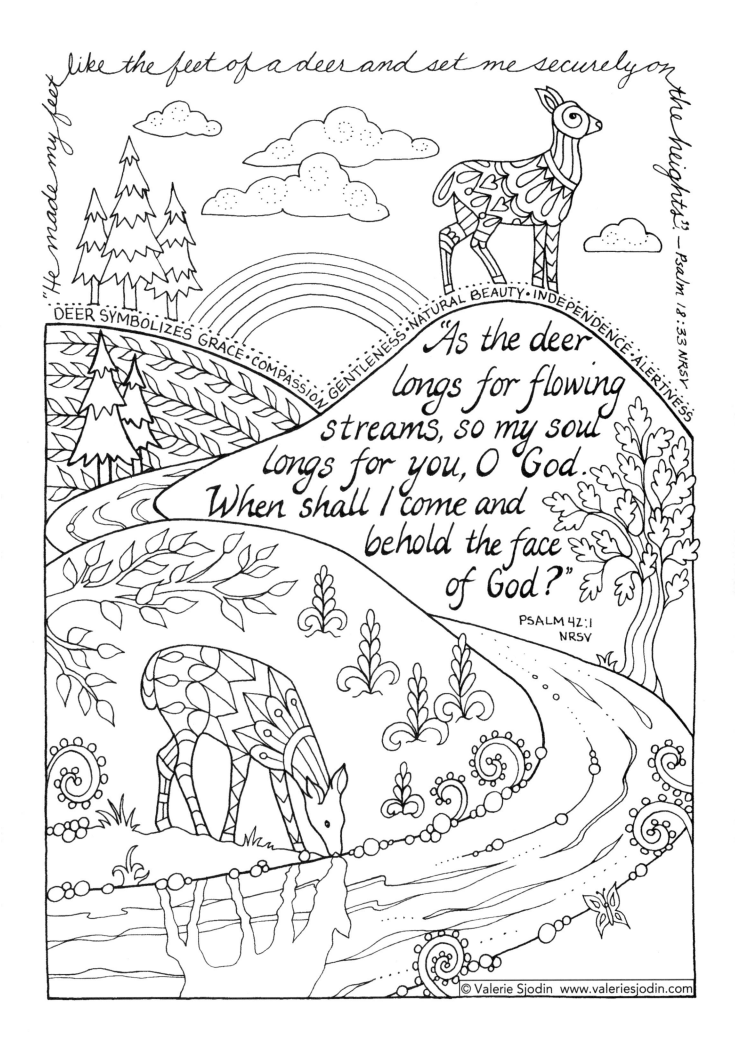

"He made my feet like the feet of a deer and set me securely on the heights." — Psalm 18:33 NRSV

DEER SYMBOLIZES GRACE • COMPASSION • GENTLENESS • NATURAL BEAUTY • INDEPENDENCE • ALERTNESS

"As the deer longs for flowing streams, so my soul longs for you, O God. When shall I come and behold the face of God?"

PSALM 42:1 NRSV

© Valerie Sjodin www.valeriesjodin.com

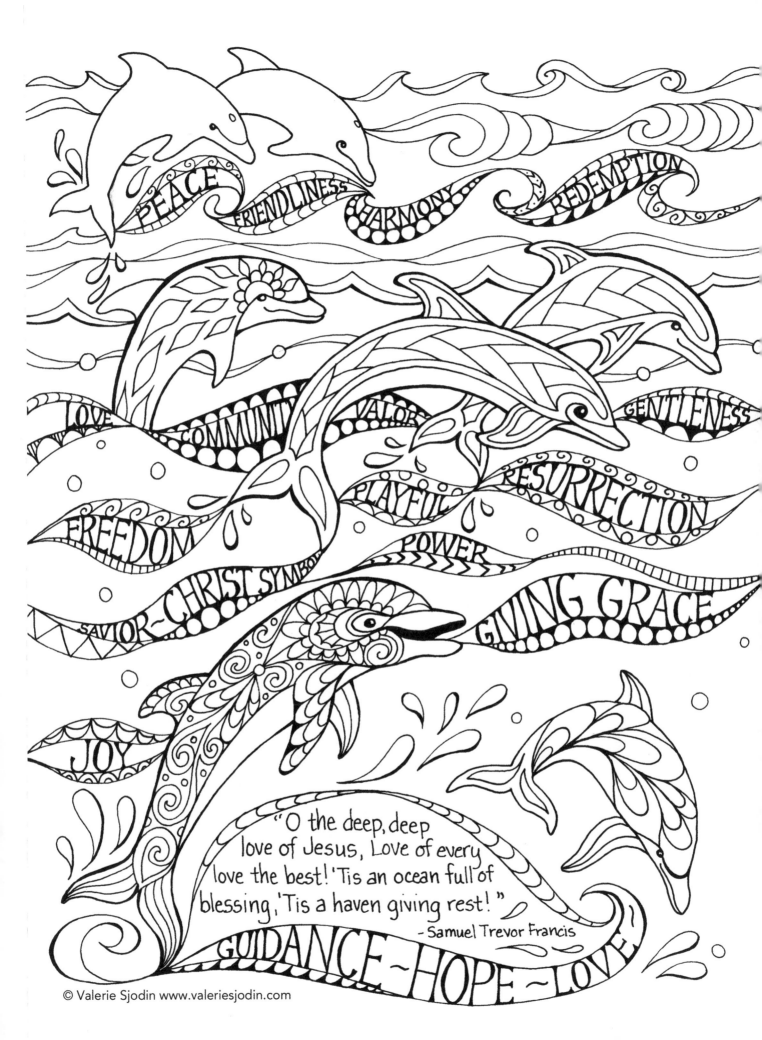

PEACE · FRIENDLINESS · HARMONY · REDEMPTION

LOVE · COMMUNITY · VALOR · GENTLENESS

PLAYFUL · RESURRECTION

FREEDOM

POWER

SAVIOR ~ CHRIST SYMBOL

GIVING GRACE

JOY

"O the deep, deep
love of Jesus, Love of every
love the best! 'Tis an ocean full of
blessing, 'Tis a haven giving rest!"
— Samuel Trevor Francis

GUIDANCE ~ HOPE ~ LOVE

© Valerie Sjodin www.valeriesjodin.com

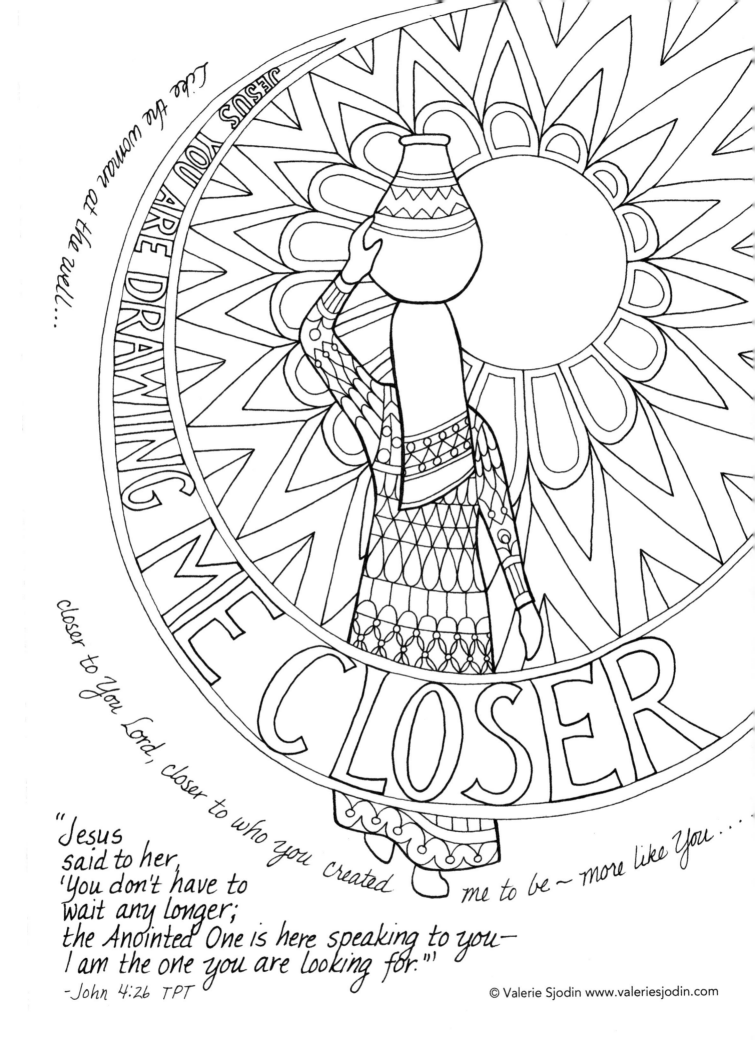

JESUS, YOU ARE DRAWING ME CLOSER

Like the woman at the well...

closer to You Lord, closer to who you created me to be ~ more like You....

"Jesus said to her, 'You don't have to wait any longer; the Anointed One is here speaking to you— I am the one you are looking for.'"

-John 4:26 TPT

© Valerie Sjodin www.valeriesjodin.com

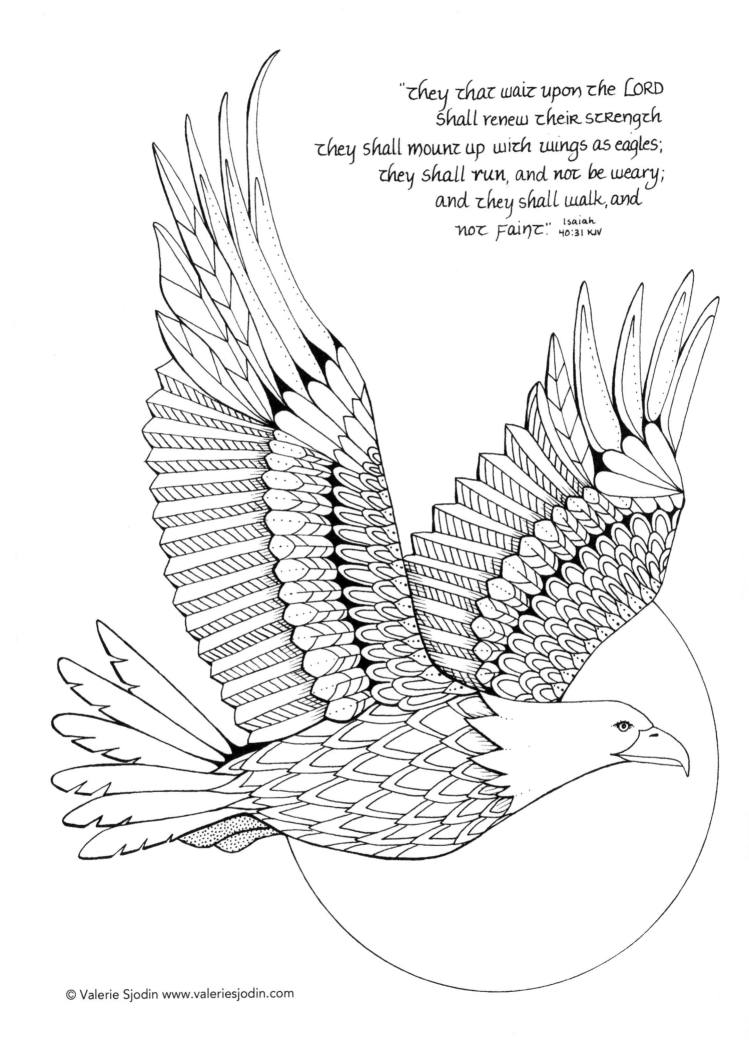

"they that wait upon the LORD
shall renew their strength
they shall mount up with wings as eagles;
they shall run, and not be weary;
and they shall walk, and
not faint." Isaiah 40:31 KJV

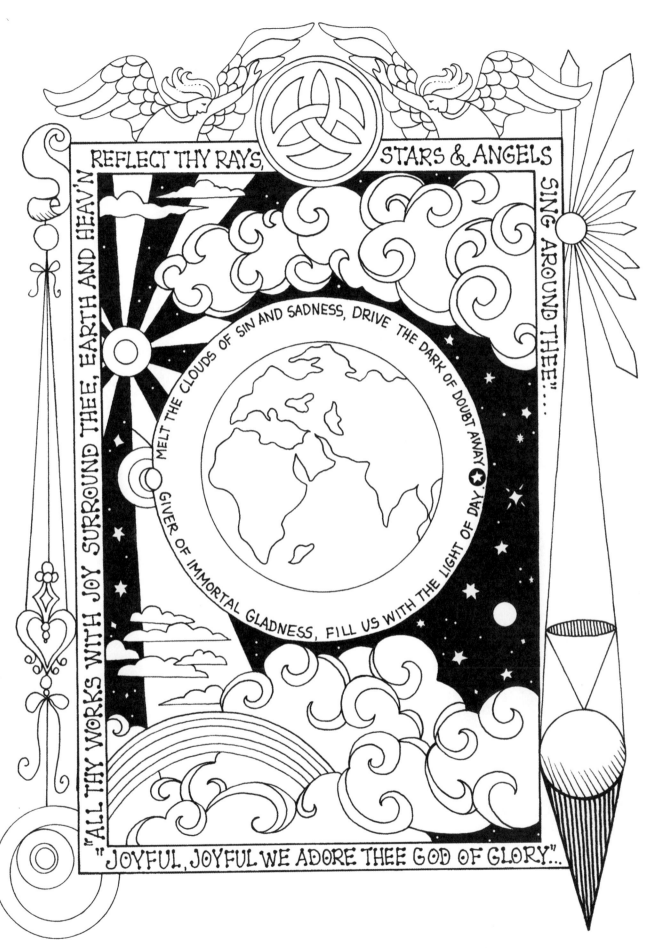

words from hymn *Joyful, Joyful, We Adore Thee* by Henry Van Dyke

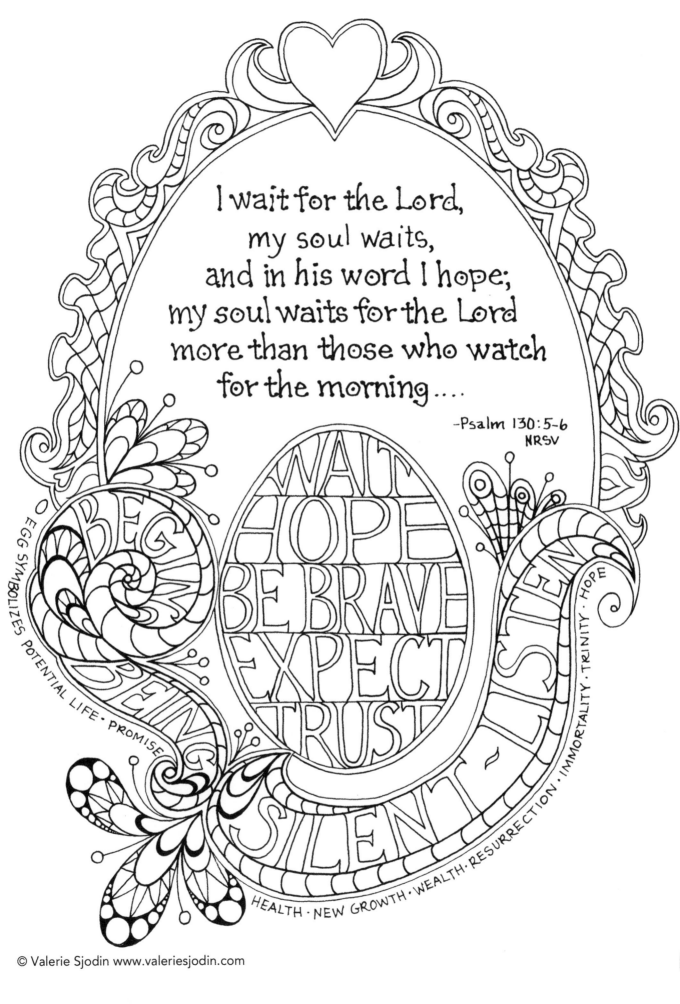

I wait for the Lord,
my soul waits,
and in his word I hope;
my soul waits for the Lord
more than those who watch
for the morning....

−Psalm 130:5-6
NRSV

WAIT
HOPE
BE BRAVE
EXPECT
TRUST

BEGIN
BEING
SILENT · LISTEN

EGG SYMBOLIZES POTENTIAL LIFE · PROMISE
HEALTH · NEW GROWTH · WEALTH · RESURRECTION · IMMORTALITY · TRINITY · HOPE

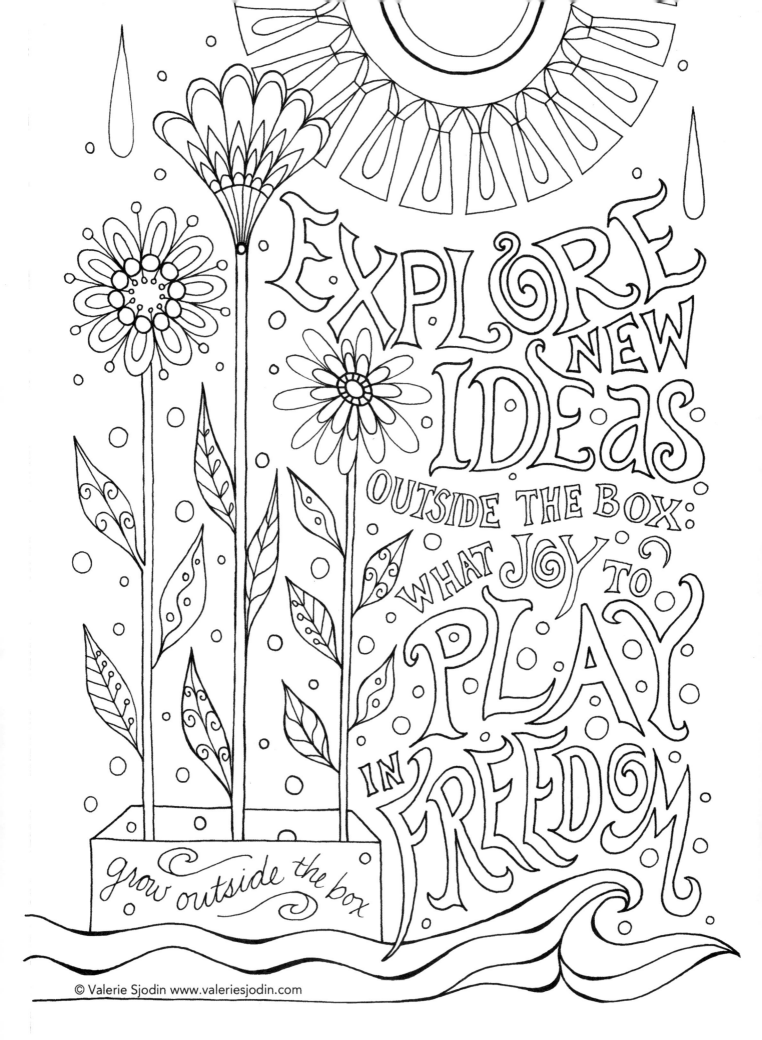

EXPLORE NEW IDEAS OUTSIDE THE BOX: WHAT JOY TO PLAY IN FREEDOM

grow outside the box

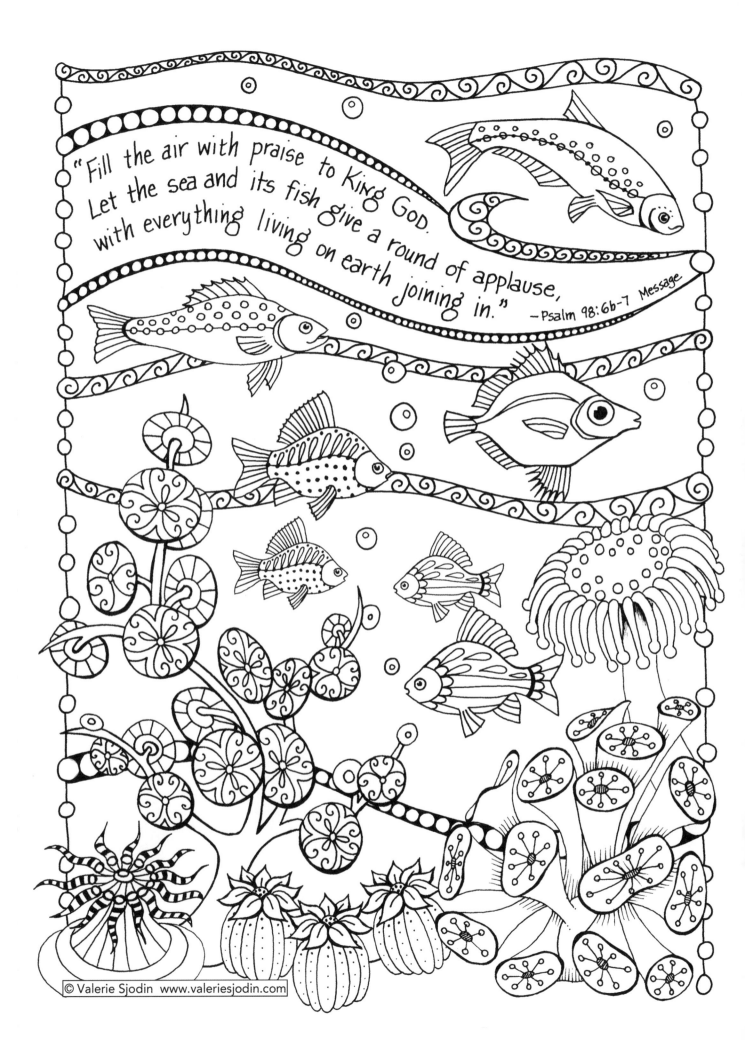

"Fill the air with praise to King God. Let the sea and its fish give a round of applause, with everything living on earth joining in." —Psalm 98:6b-7 Message

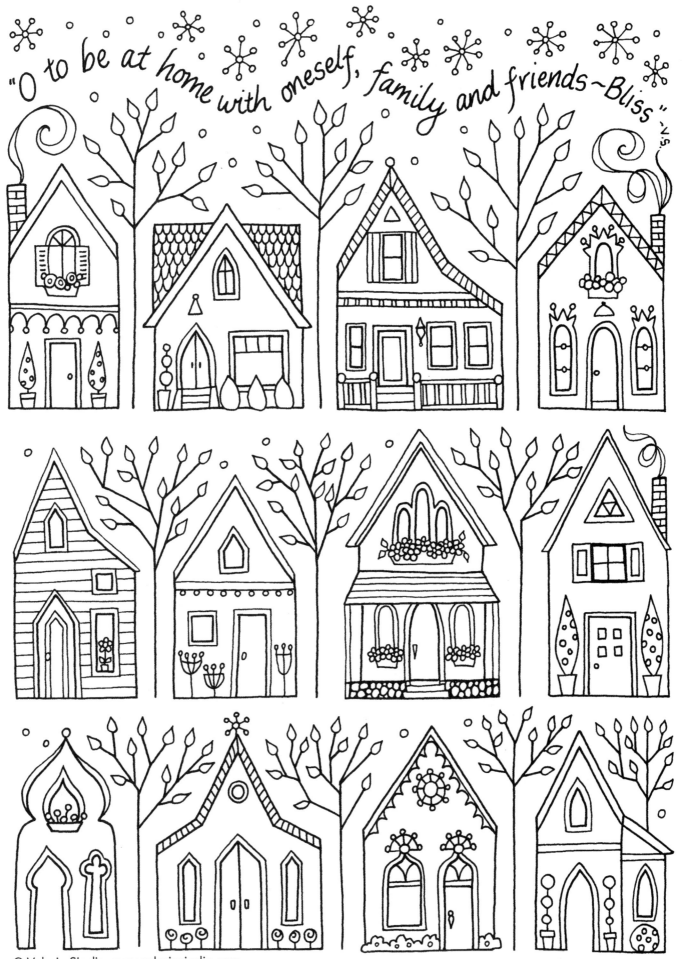

"O to be at home with oneself, family and friends ~Bliss" ~V.S.

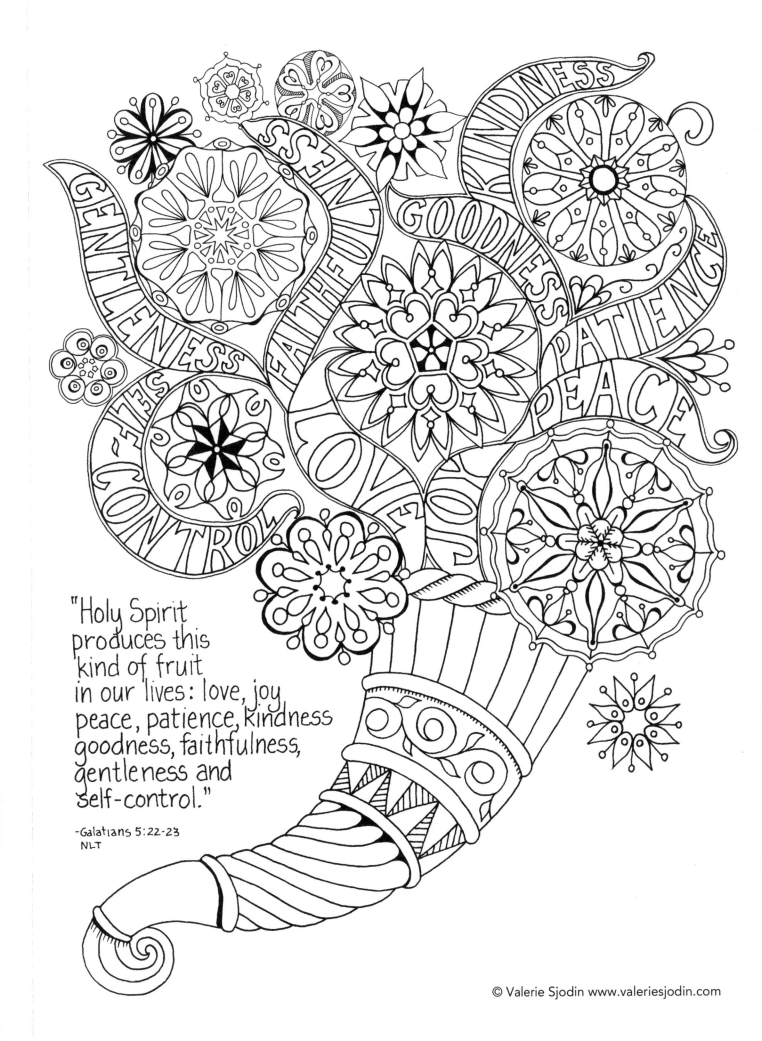

"Holy Spirit
produces this
kind of fruit
in our lives: love, joy
peace, patience, kindness
goodness, faithfulness,
gentleness and
self-control."

-Galatians 5:22-23
NLT

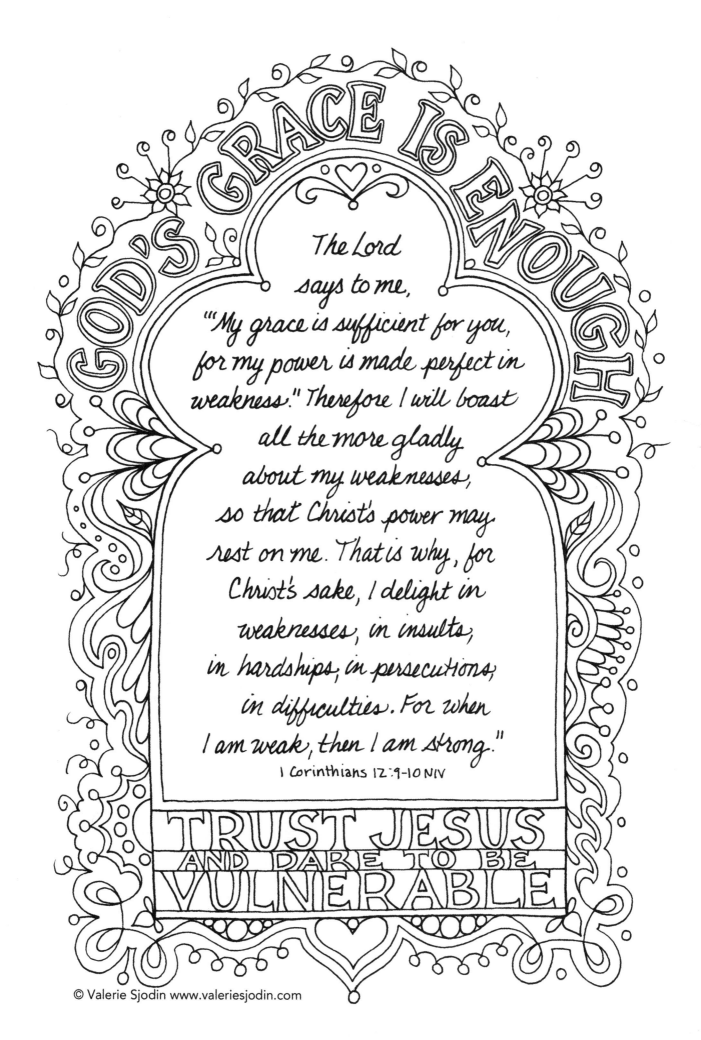

GOD'S GRACE IS ENOUGH

The Lord says to me, "'My grace is sufficient for you, for my power is made perfect in weakness." Therefore I will boast all the more gladly about my weaknesses, so that Christ's power may rest on me. That is why, for Christ's sake, I delight in weaknesses, in insults, in hardships, in persecutions, in difficulties. For when I am weak, then I am strong."

1 Corinthians 12:9-10 NIV

TRUST JESUS AND DARE TO BE VULNERABLE

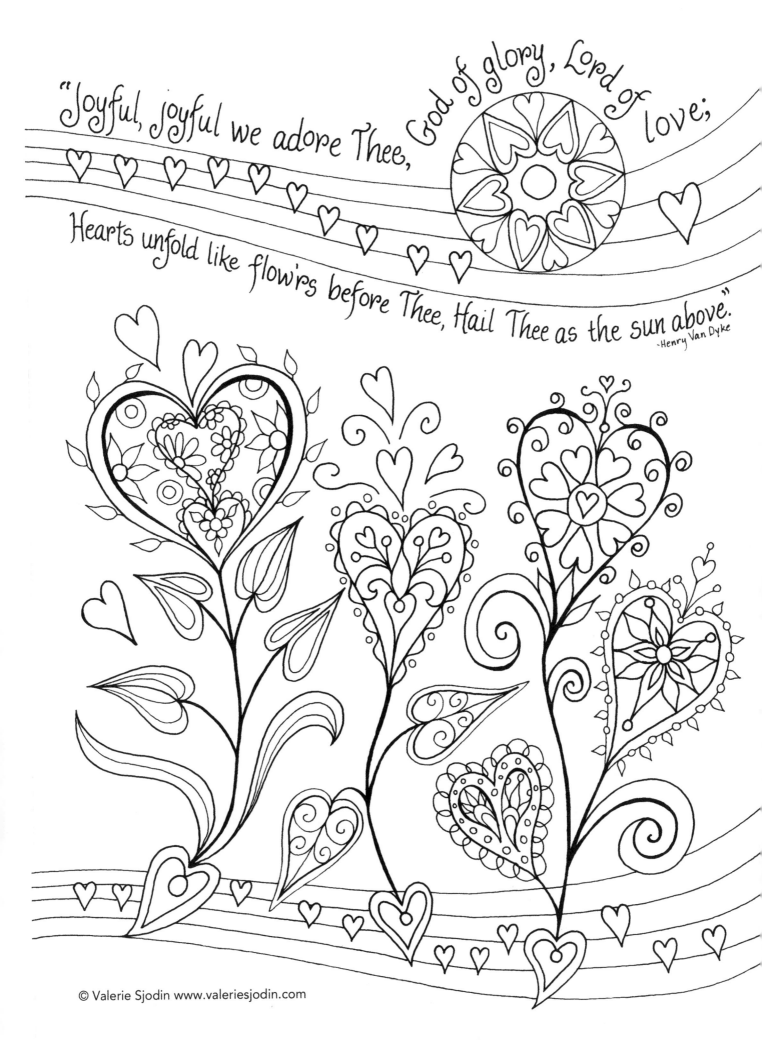

"Joyful, joyful we adore Thee, God of glory, Lord of love;

Hearts unfold like flow'rs before Thee, Hail Thee as the sun above."
-Henry Van Dyke

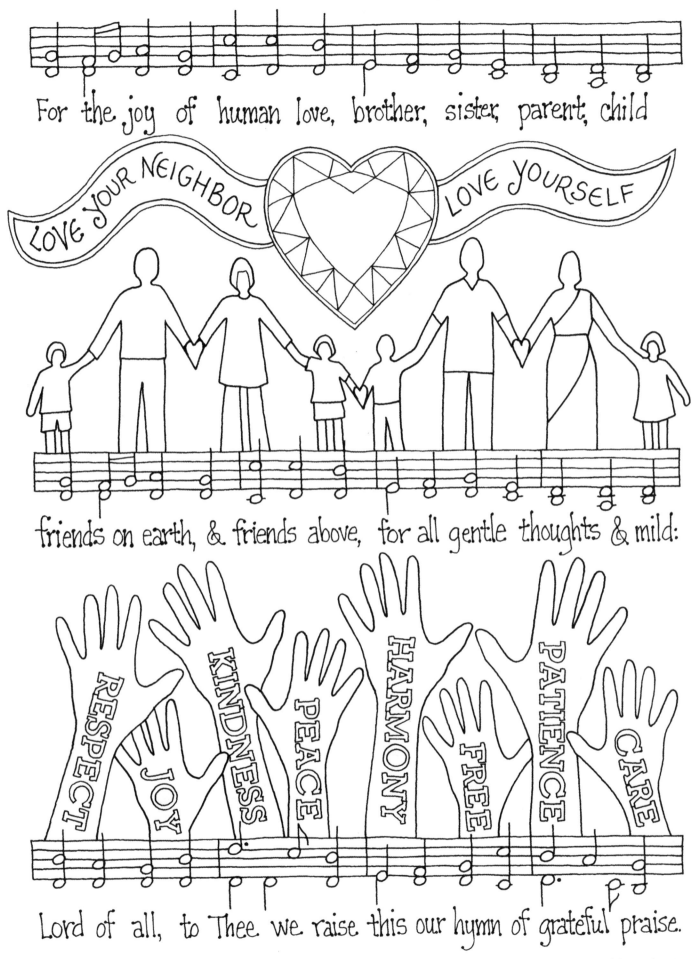

© Valerie Sjodin www.valeriesjodin.com

Music text by Folliott Sandford Pierpoint, "For the Beauty of the Earth" 1864
Music: Conrad Kocher 1838, William Henry Monk, 1861

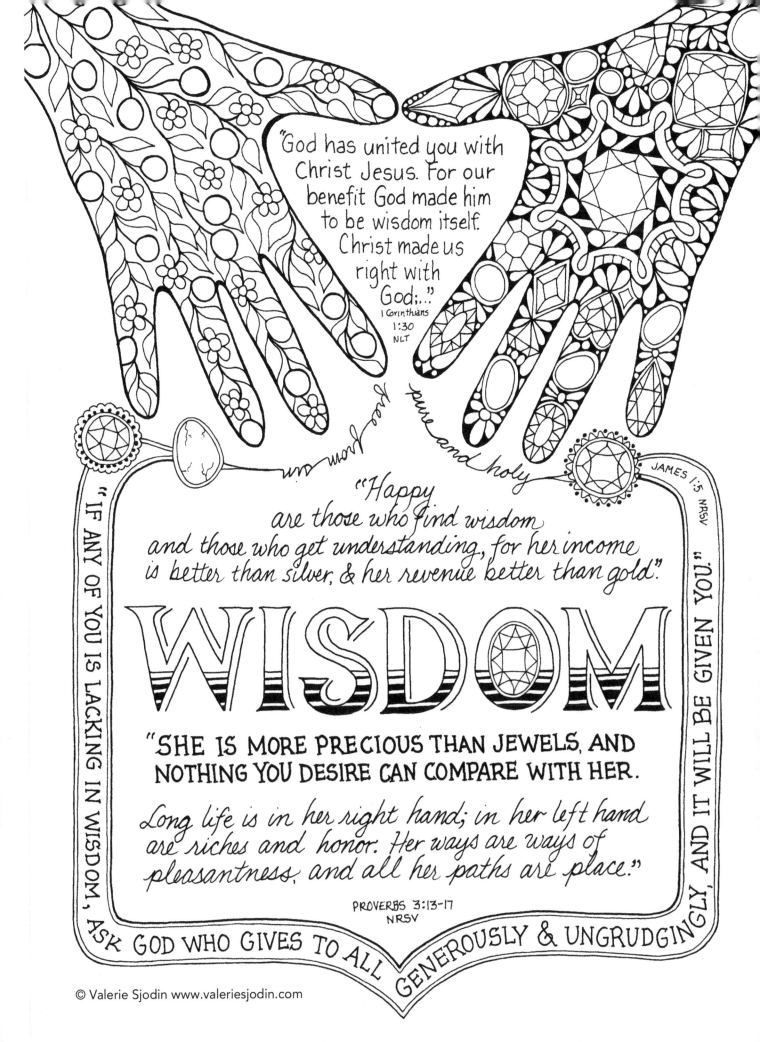

"God has united you with Christ Jesus. For our benefit God made him to be wisdom itself. Christ made us right with God;..."
1 Corinthians 1:30 NLT

"Happy are those who find wisdom and those who get understanding, for her income is better than silver, & her revenue better than gold".

WISDOM

"SHE IS MORE PRECIOUS THAN JEWELS, AND NOTHING YOU DESIRE CAN COMPARE WITH HER.

Long life is in her right hand; in her left hand are riches and honor. Her ways are ways of pleasantness, and all her paths are place."

PROVERBS 3:13-17 NRSV

"IF ANY OF YOU IS LACKING IN WISDOM, ASK GOD WHO GIVES TO ALL GENEROUSLY & UNGRUDGINGLY, AND IT WILL BE GIVEN YOU."
JAMES 1:5 NRSV

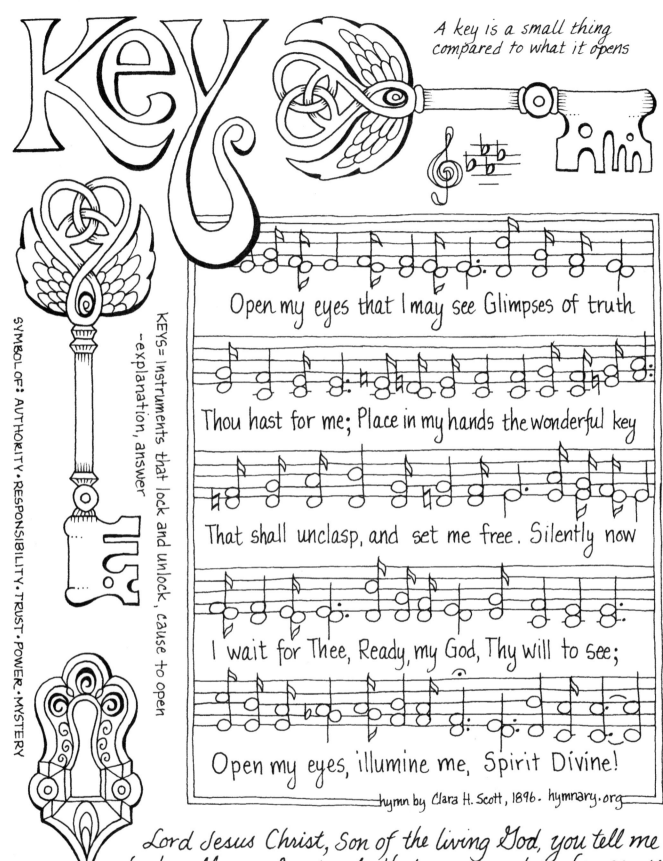

Keys

A key is a small thing compared to what it opens

SYMBOL OF: AUTHORITY • RESPONSIBILITY • TRUST • POWER • MYSTERY

KEYS = Instruments that lock and unlock, cause to open —explanation, answer

Open my eyes that I may see Glimpses of truth

Thou hast for me; Place in my hands the wonderful key

That shall unclasp, and set me free. Silently now

I wait for Thee, Ready, my God, Thy will to see;

Open my eyes, illumine me, Spirit Divine!

hymn by Clara H. Scott, 1896. hymnary.org

Lord Jesus Christ, Son of the living God, you tell me who I really am & not only that, you grant me free access to God's Kingdom of heaven, keys to open any and every door, no more barriers between heaven and earth, earth and heaven.

— my prayer based on Matthew 16:17-19, The Message Bible

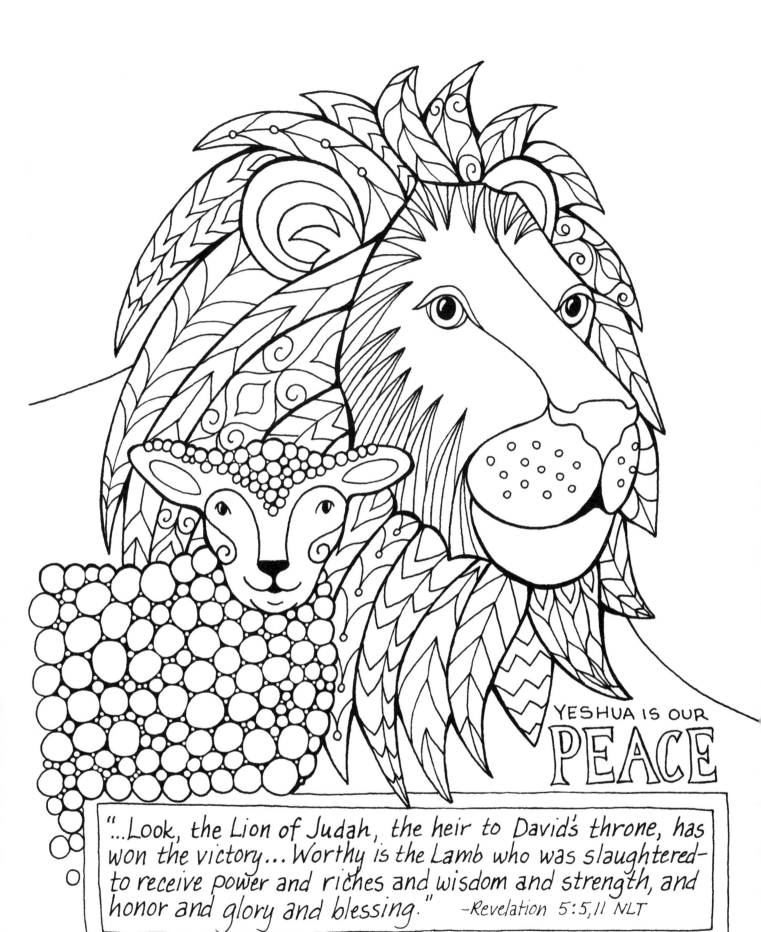

YESHUA IS OUR
PEACE

"...Look, the Lion of Judah, the heir to David's throne, has
won the victory... Worthy is the Lamb who was slaughtered—
to receive power and riches and wisdom and strength, and
honor and glory and blessing." —Revelation 5:5,11 NLT

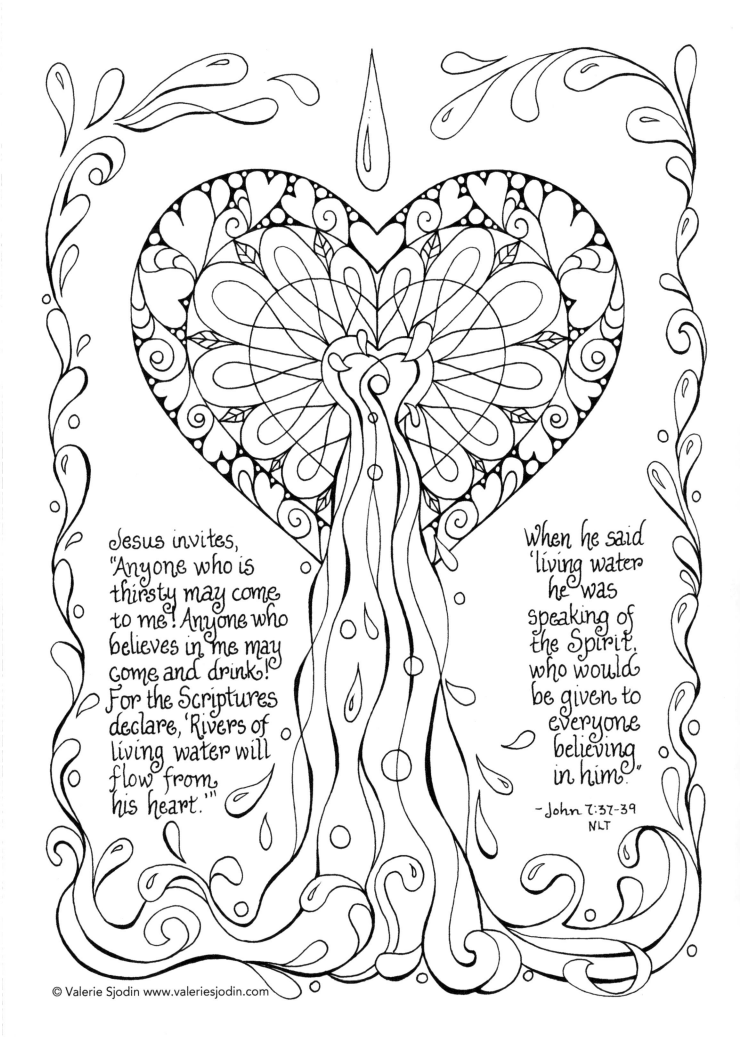

Jesus invites, "Anyone who is thirsty may come to me! Anyone who believes in me may come and drink! For the Scriptures declare, 'Rivers of living water will flow from his heart.'"

When he said 'living water' he was speaking of the Spirit, who would be given to everyone believing in him."

– John 7:37-39 NLT

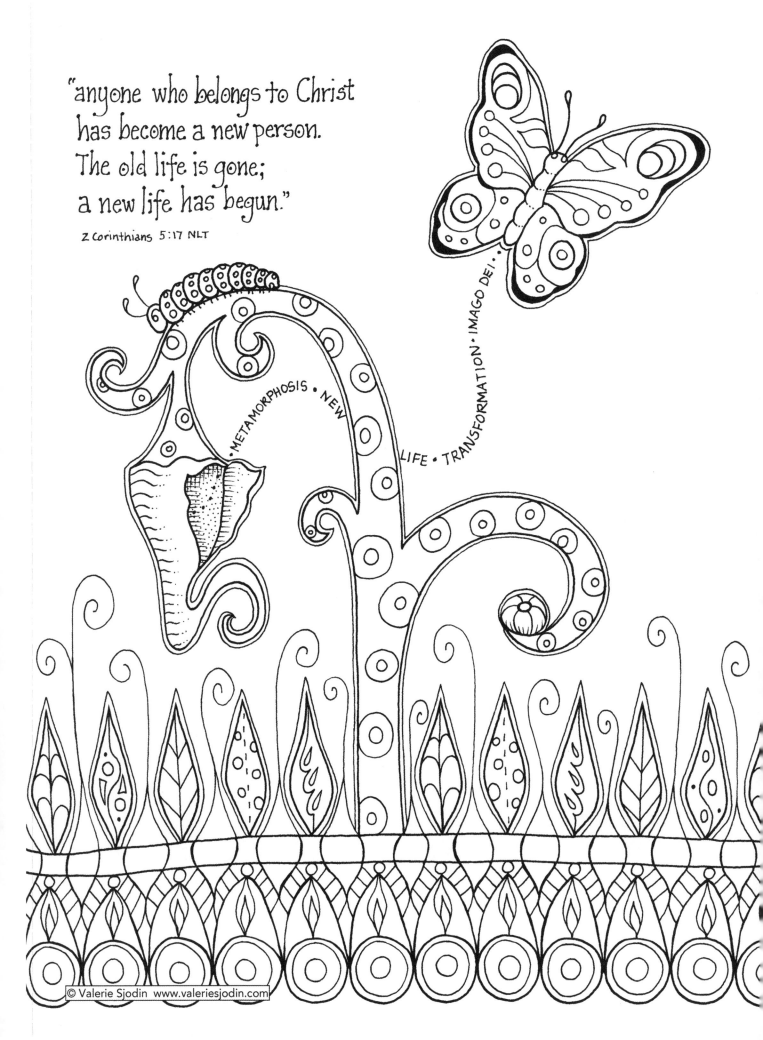

"anyone who belongs to Christ
has become a new person.
The old life is gone;
a new life has begun."

2 Corinthians 5:17 NLT

METAMORPHOSIS • NEW LIFE • TRANSFORMATION • IMAGO DEI

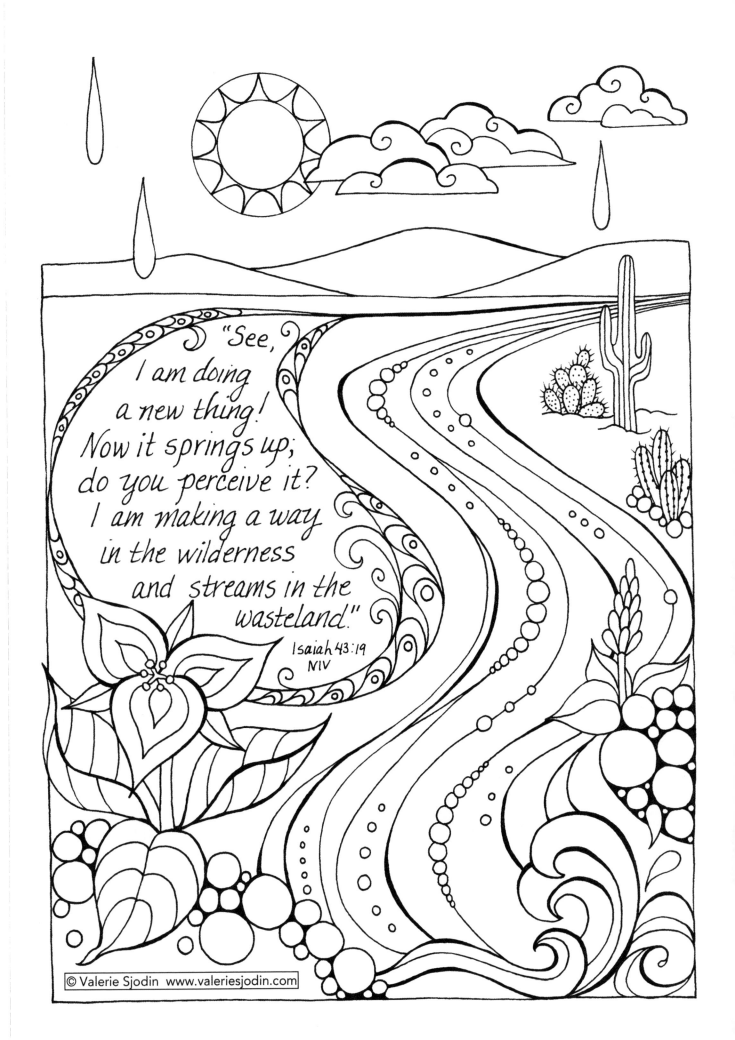

"See, I am doing a new thing! Now it springs up; do you perceive it? I am making a way in the wilderness and streams in the wasteland."

Isaiah 43:19
NIV

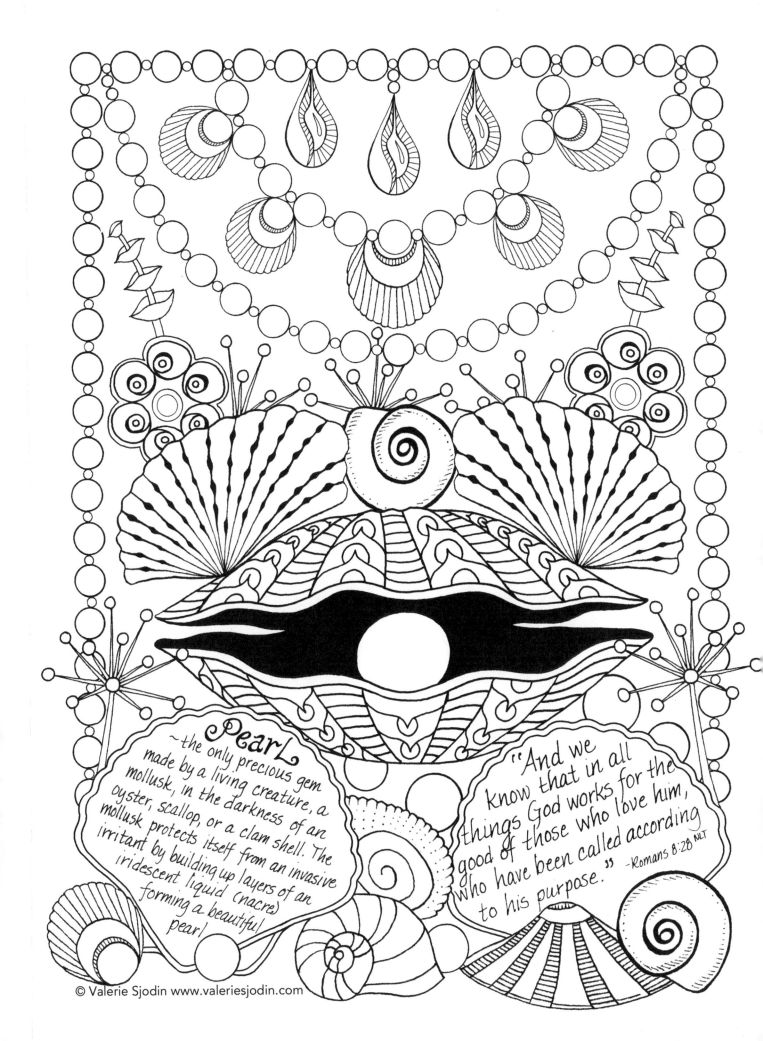

Pearl
~the only precious gem made by a living creature, a mollusk, in the darkness of an oyster, scallop, or a clam shell. The mollusk protects itself from an invasive irritant by building up layers of an iridescent liquid (nacre) forming a beautiful pearl!

"And we know that in all things God works for the good of those who love him, who have been called according to his purpose." —Romans 8:28 NLT

THIS IS MY FATHER'S WORLD

"THIS IS MY FATHER'S WORLD, AND TO MY LIST'NING EARS, ALL NATURE SINGS AND ROUND ME RINGS THE MUSIC OF THE SPHERES." —Maltbie D. Babcock

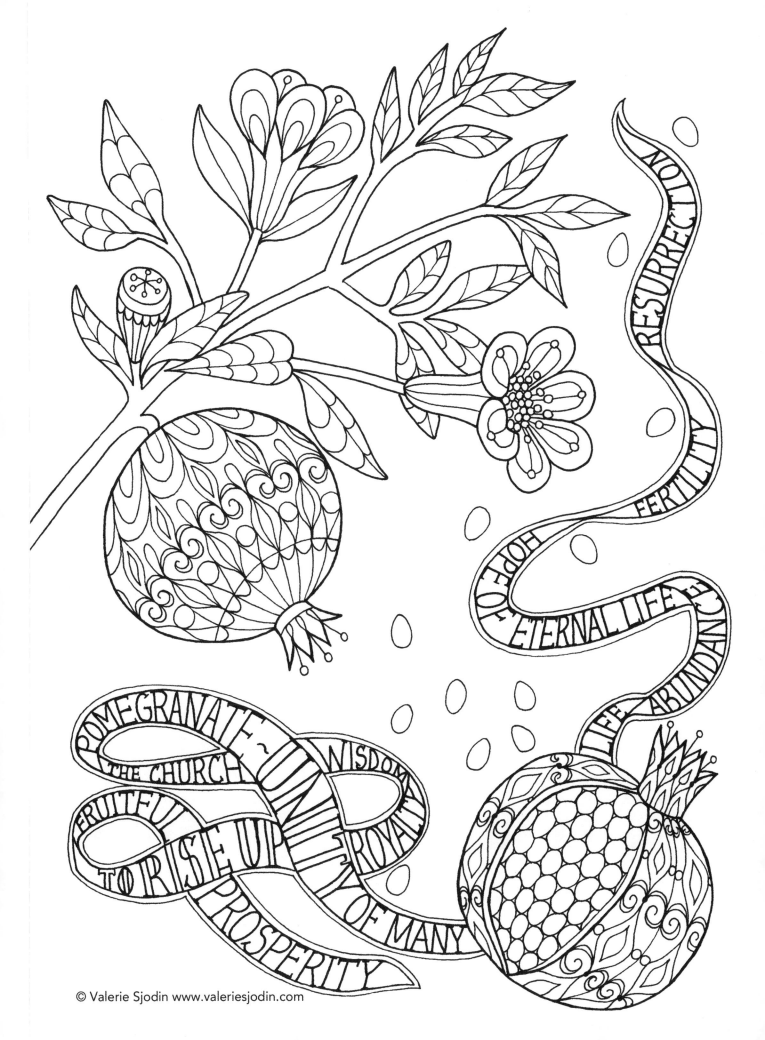

RESURRECTION

FERTILITY

HOPE OF ETERNAL LIFE

LIFE ABUNDANT

POMEGRANATE · UNITY

THE CHURCH

WISDOM

ROYAL

FRUITFUL

TO RISE UP

OF MANY

PROSPERITY

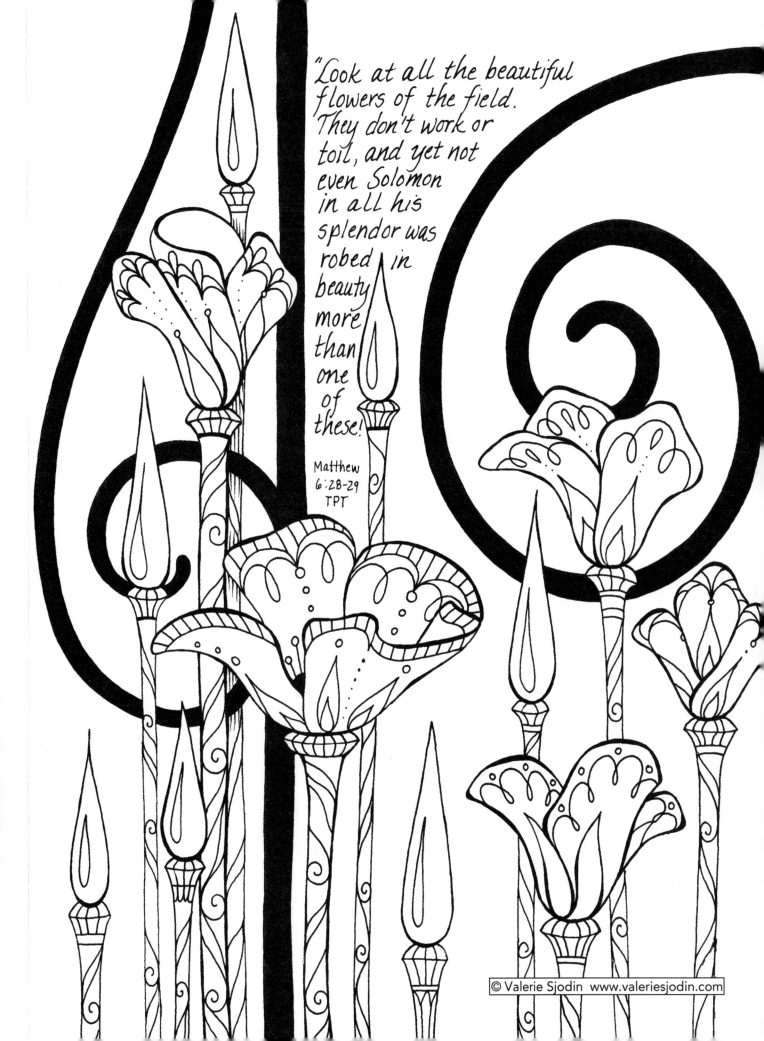

"Look at all the beautiful flowers of the field. They don't work or toil, and yet not even Solomon in all his splendor was robed in beauty more than one of these!"

Matthew 6:28-29 TPT

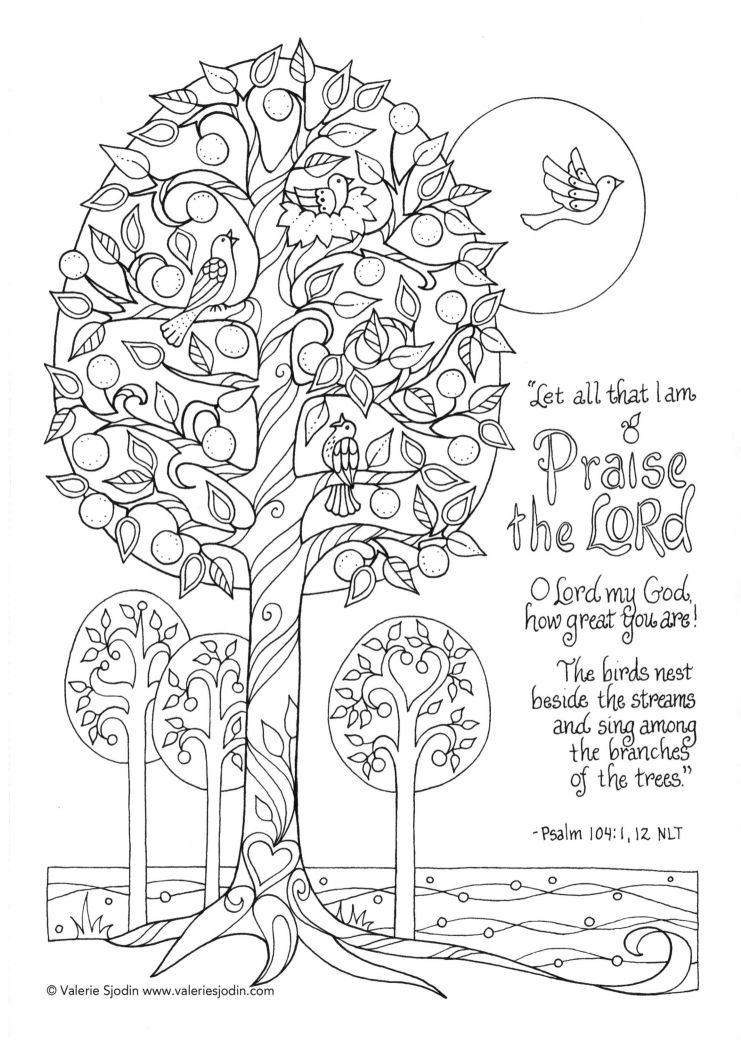

"Let all that I am
&
Praise
the LORd

O Lord my God,
how great you are!

The birds nest
beside the streams
and sing among
the branches
of the trees."

- Psalm 104:1, 12 NLT

© Valerie Sjodin www.valeriesjodin.com

...where morning dawns & evening fades...

...You call forth songs of joy." —Psalm 65:8b NIV

© Valerie Sjodin www.valeriesjodin.com

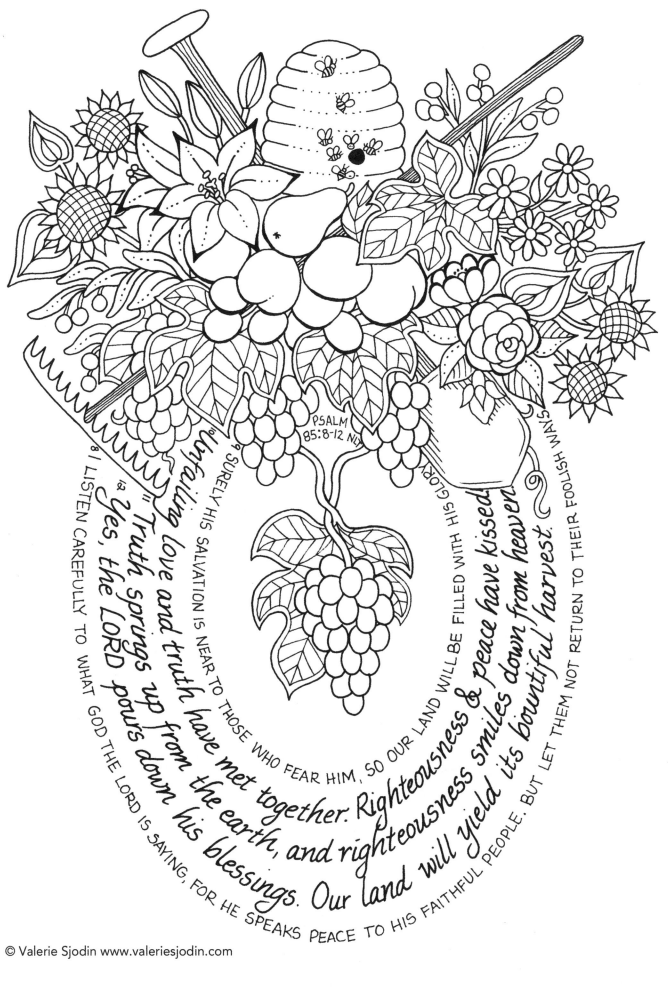

PSALM 85:8-12 NLT

⁸ I LISTEN CAREFULLY TO WHAT GOD THE LORD IS SAYING, FOR HE SPEAKS PEACE TO HIS FAITHFUL PEOPLE. BUT LET THEM NOT RETURN TO THEIR FOOLISH WAYS. ⁹ SURELY HIS SALVATION IS NEAR TO THOSE WHO FEAR HIM, SO OUR LAND WILL BE FILLED WITH HIS GLORY. ¹⁰ "Unfailing love and truth have met together. Righteousness & peace have kissed. ¹¹ Truth springs up from the earth, and righteousness smiles down from heaven. ¹² Yes, the LORD pours down his blessings. Our land will yield its bountiful harvest.

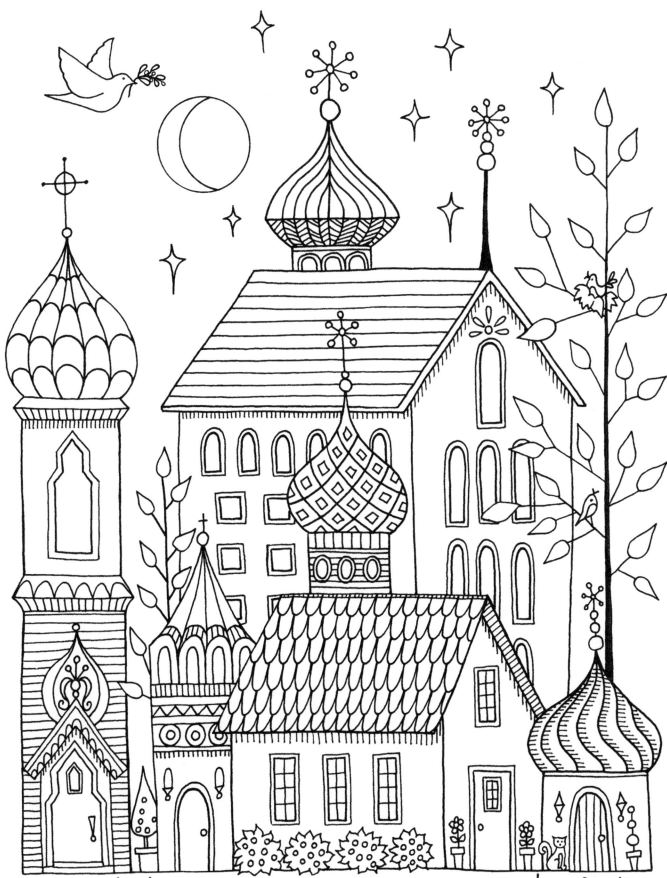

"He is the happiest, be he king or peasant, who finds peace in his home." -Goethe

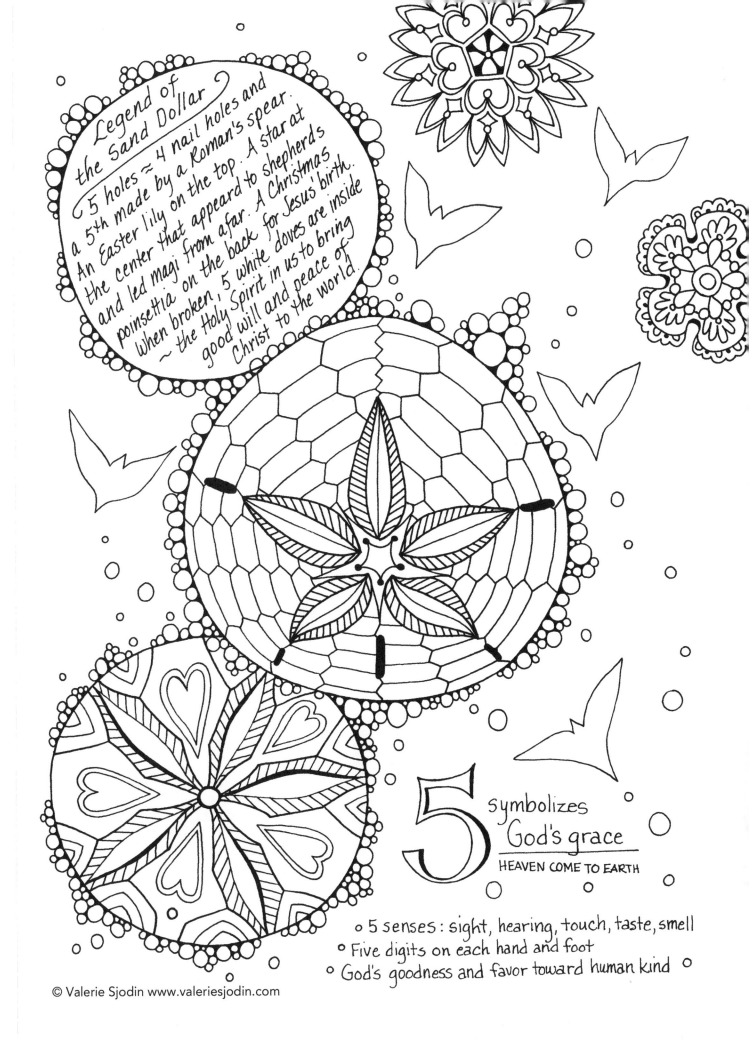

Legend of the Sand Dollar

5 holes = 4 nail holes and a 5th made by a Roman's spear. An Easter lily on the top. A star at the center that appeared to shepherds and led magi from afar. A Christmas poinsettia on the back for Jesus' birth. When broken, 5 white doves are inside ~ the Holy Spirit in us to bring good will and peace of Christ to the world.

5 symbolizes God's grace
HEAVEN COME TO EARTH

○ 5 senses: sight, hearing, touch, taste, smell
○ Five digits on each hand and foot
○ God's goodness and favor toward human kind

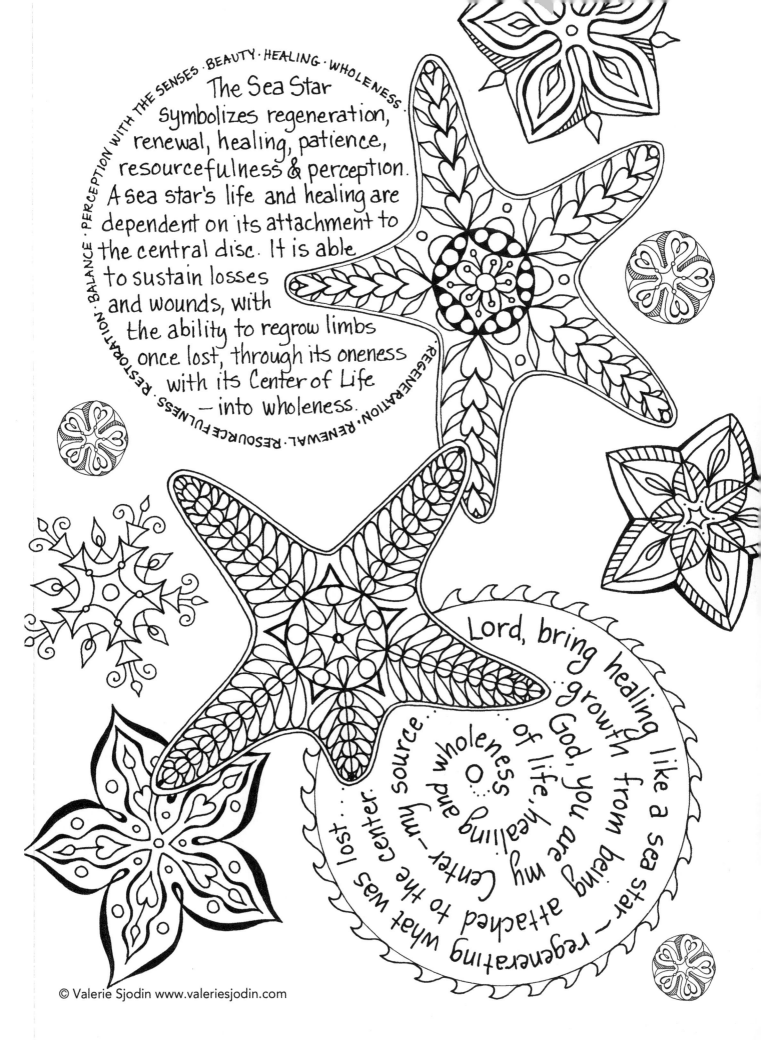

PERCEPTION WITH THE SENSES · BEAUTY · HEALING · WHOLENESS ·

BALANCE · RESTORATION · REGENERATION · RENEWAL · RESOURCEFULNESS ·

The Sea Star
symbolizes regeneration,
renewal, healing, patience,
resourcefulness & perception.
A sea star's life and healing are
dependent on its attachment to
the central disc. It is able
to sustain losses
and wounds, with
the ability to regrow limbs
once lost, through its oneness
with its Center of Life
— into wholeness.

Lord, bring healing like a sea star — regenerating what was lost... healing and bringing growth from being attached to the center — my source. wholeness O God, you are my Center — my source. of life.

© Valerie Sjodin www.valeriesjodin.com

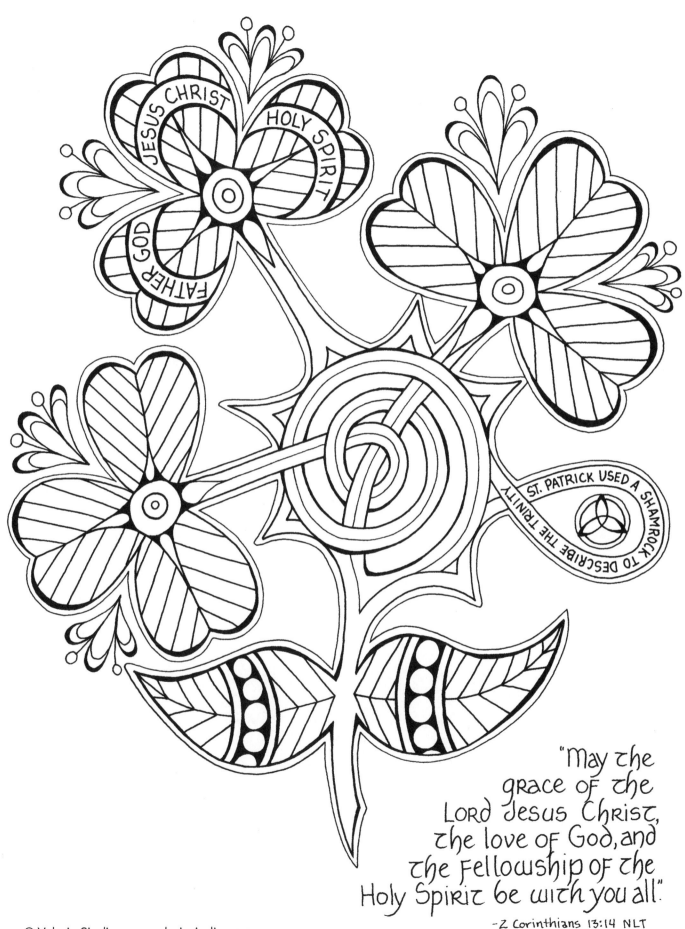

JESUS CHRIST HOLY SPIRIT FATHER GOD

ST. PATRICK USED A SHAMROCK TO DESCRIBE THE TRINITY

"May the grace of the Lord Jesus Christ, the love of God, and the Fellowship of the Holy Spirit be with you all."

—2 Corinthians 13:14 NLT

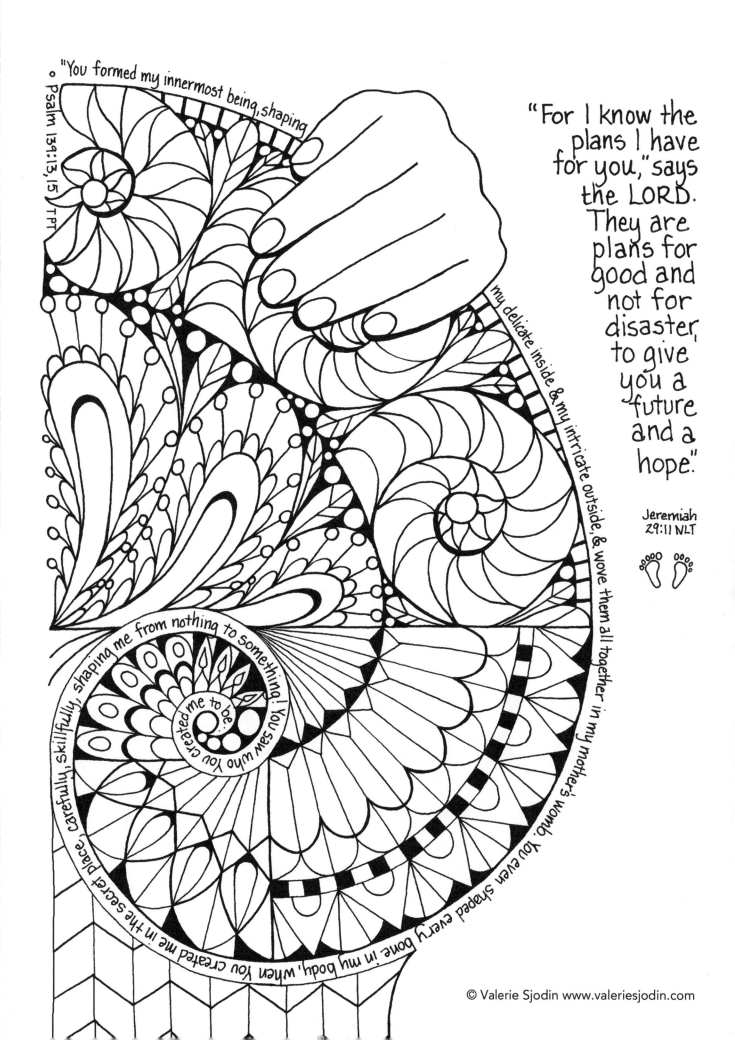

"You formed my innermost being, shaping

Psalm 139:13,15 TPT

"For I know the plans I have for you," says the LORD. They are plans for good and not for disaster, to give you a future and a hope."

Jeremiah 29:11 NLT

my delicate inside & my intricate outside, & wove them all together in my mother's womb. You even shaped every bone in my body, when you created me in the secret place, carefully, skillfully, shaping me from nothing to something! You saw who You created me to be.

© Valerie Sjodin www.valeriesjodin.com

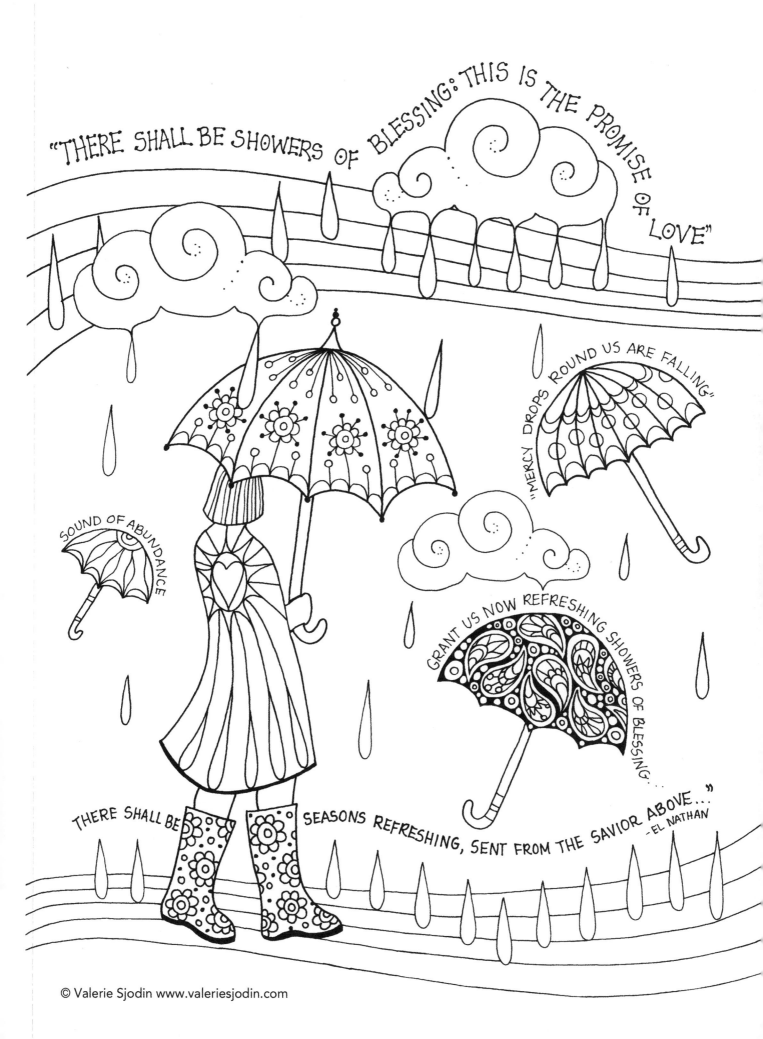

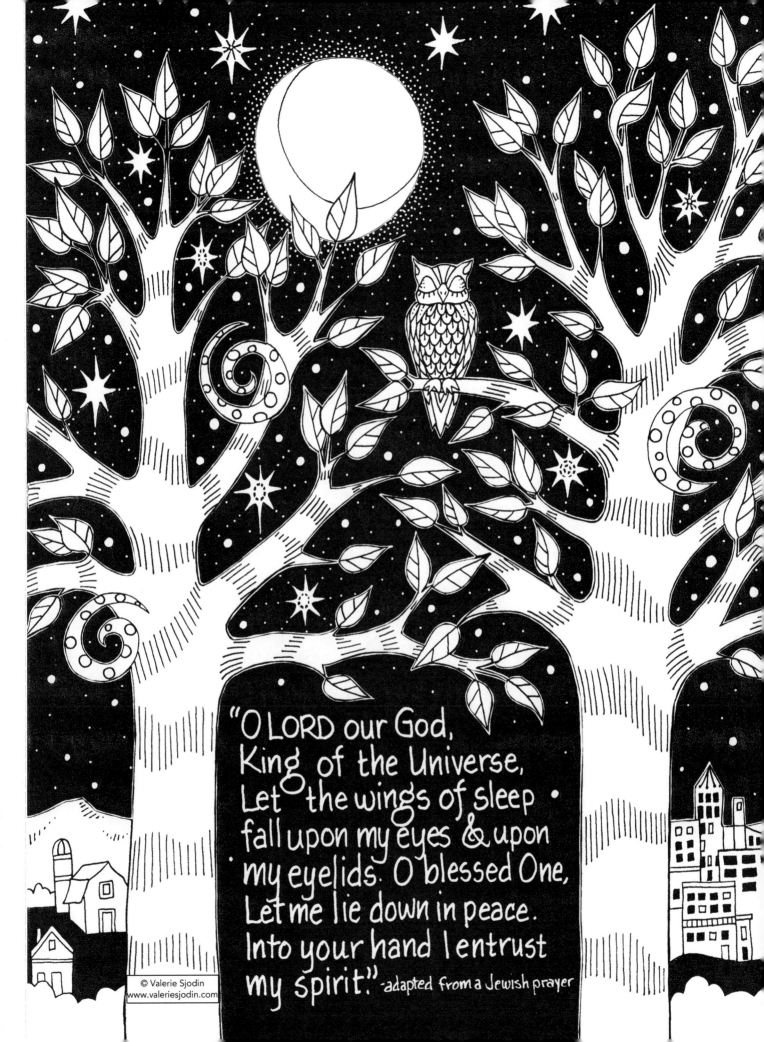

"O LORD our God, King of the Universe, Let the wings of sleep fall upon my eyes & upon my eyelids. O blessed One, Let me lie down in peace. Into your hand I entrust my spirit." -adapted from a Jewish prayer

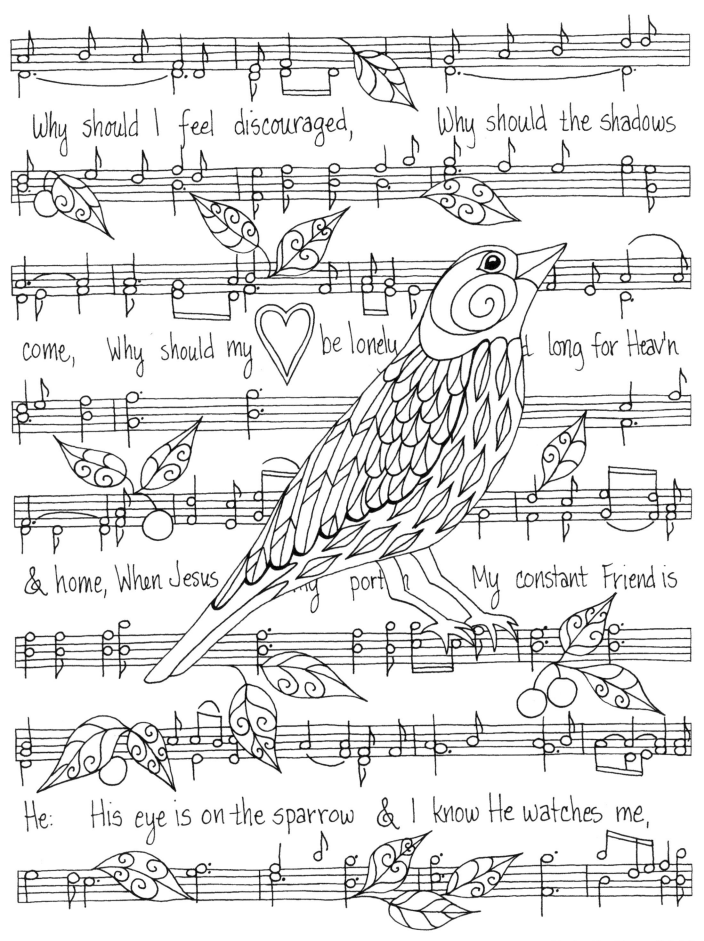

Lyrics & Music: Civilla Durfee Martin, 1905 Charles Hutchinson Gabriel

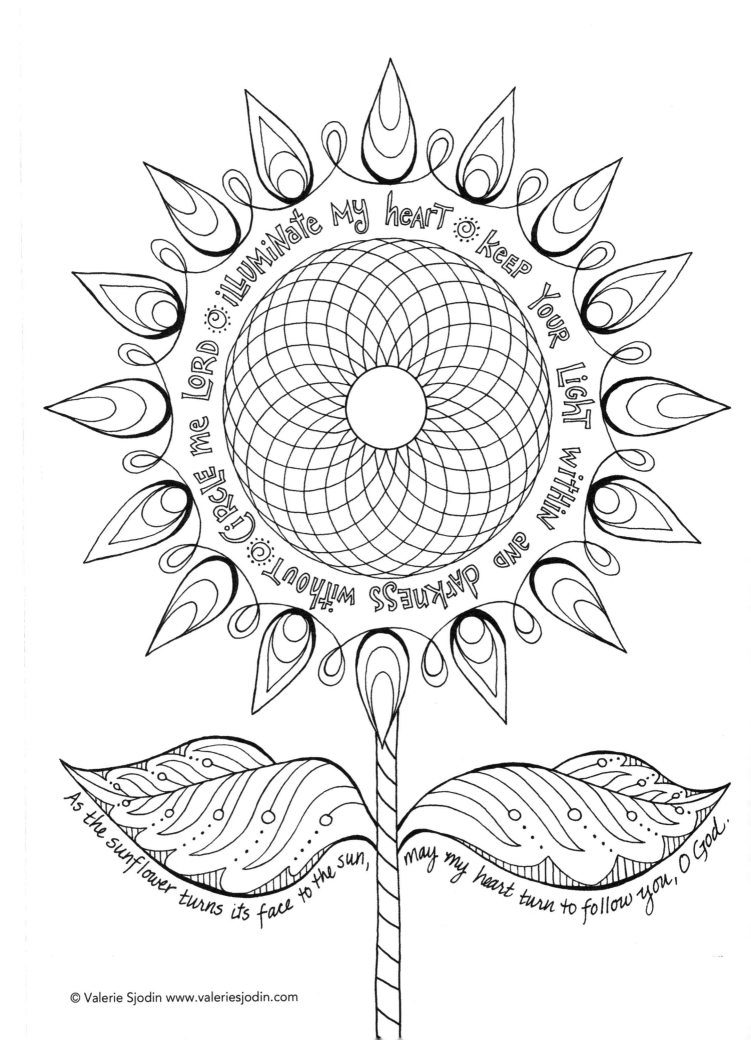

illuMiNate My heArT · keep Your light within and darkness without · CircLe me LORD ·

As the sunflower turns its face to the sun, may my heart turn to follow you, O God.

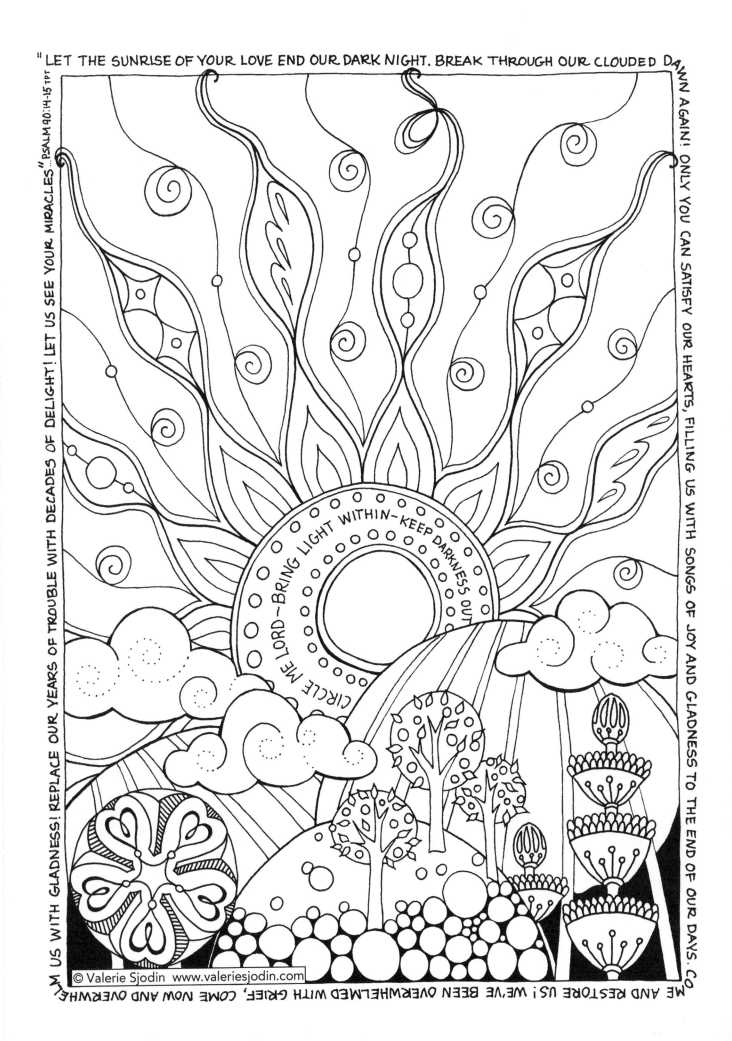

"LET THE SUNRISE OF YOUR LOVE END OUR DARK NIGHT. BREAK THROUGH OUR CLOUDED DAWN AGAIN! ONLY YOU CAN SATISFY OUR HEARTS, FILLING US WITH SONGS OF JOY AND GLADNESS TO THE END OF OUR DAYS. COME AND RESTORE US! WE'VE BEEN OVERWHELMED WITH GRIEF. COME NOW AND OVERWHELM US WITH GLADNESS! REPLACE OUR YEARS OF TROUBLE WITH DECADES OF DELIGHT! LET US SEE YOUR MIRACLES"...PSALM 90:14-15 TPT

CIRCLE ME LORD—BRING LIGHT WITHIN—KEEP DARKNESS OUT

© Valerie Sjodin www.valeriesjodin.com

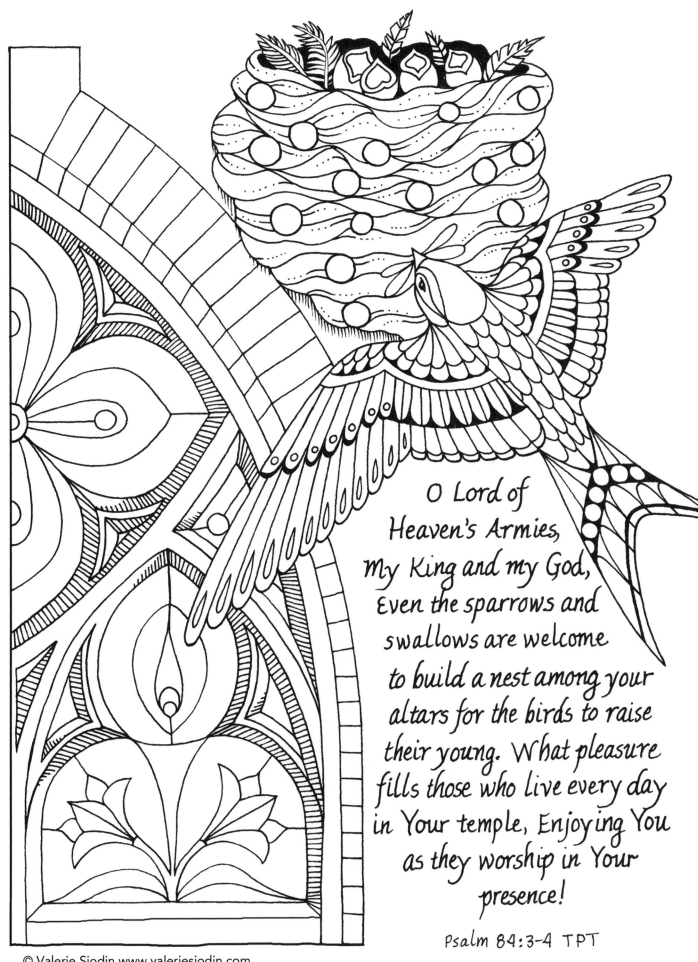

O Lord of
Heaven's Armies,
My King and my God,
Even the sparrows and
swallows are welcome
to build a nest among your
altars for the birds to raise
their young. What pleasure
fills those who live every day
in Your temple, Enjoying You
as they worship in Your
presence!

Psalm 84:3-4 TPT

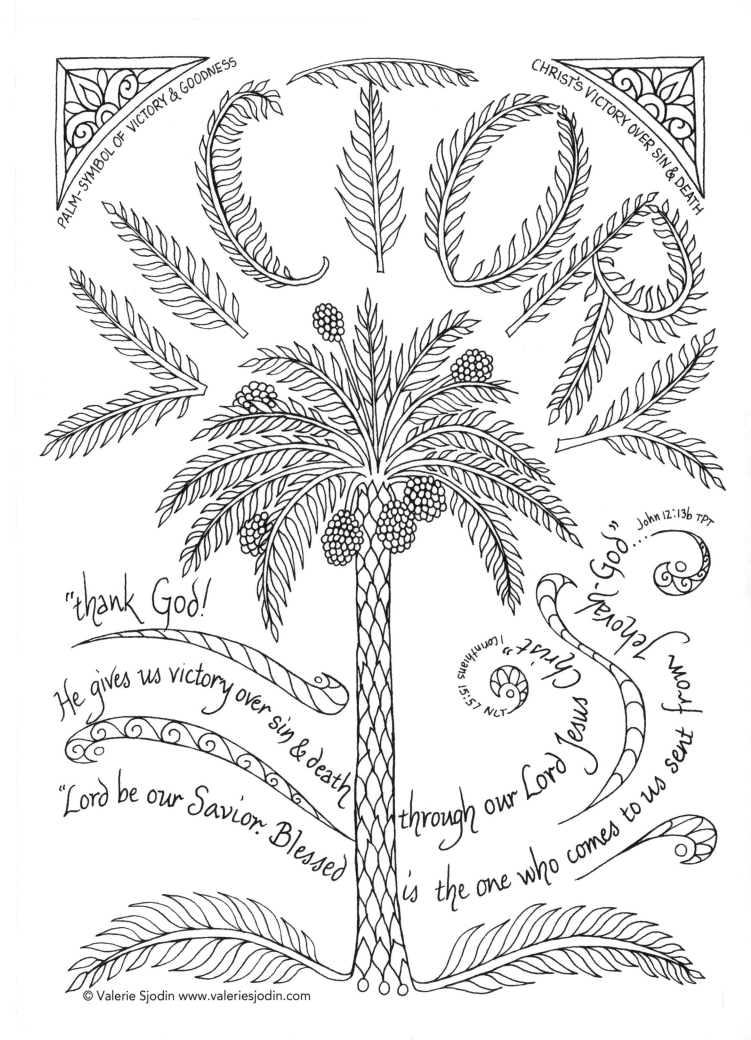

PALM-SYMBOL OF VICTORY & GOODNESS

CHRIST'S VICTORY OVER SIN & DEATH

"thank God!

He gives us victory over sin & death

"Lord be our Savior. Blessed

through our Lord Jesus Christ." 1Corinthians 15:57 NLT

is the one who comes to us sent from Jehovah-God." John 12:13b TPT

© Valerie Sjodin www.valeriesjodin.com

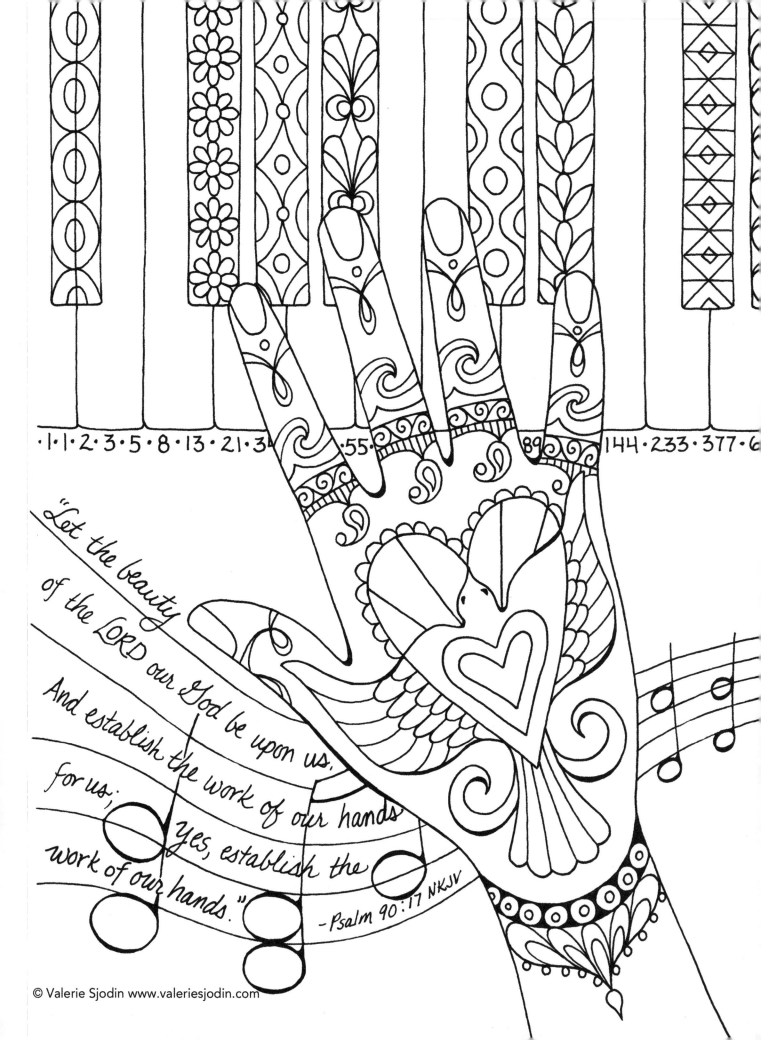

·1·1·2·3·5·8·13·21·3... ·55· 89 ·144·233·377·6...

"Let the beauty of the LORD our God be upon us, And establish the work of our hands for us; Yes, establish the work of our hands."
— Psalm 90:17 NKJV

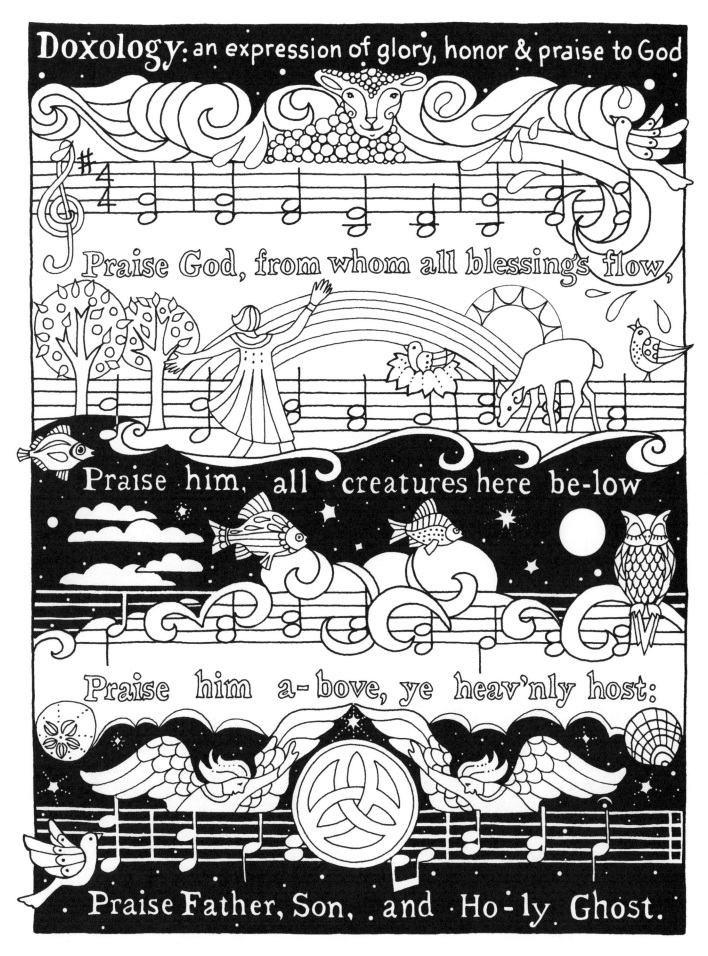

Words: Thomas Ken, Music: Louis Bourgeois